IMAGES
of America

CUMBERLAND

IMAGES
of America

CUMBERLAND

Amanda Paul

ARCADIA

Published by Arcadia Publishing
an imprint of Tempus Publishing Inc.
Charleston SC, Chicago, Portsmouth NH, San Francisco

Printed in Great Britain

Library of Congress Catalog Card Number: 2002115605

For all general information contact Arcadia Publishing at:
Telephone 843-853-2070
Fax 843-853-0044
E-mail sales@arcadiapublishing.com
For customer service and orders:
Toll-Free 1-888-313-2665

Visit us on the internet at http://www.arcadiapublishing.com

CONTENTS

ACKNOWLEDGMENTS

The greatest thanks go to the following individuals and entities that allowed the use of their materials: Sharon Nealis, director of the Allegany County Historical Society; Kathy McKenney, historic planner at the City of Cumberland (Hermon & Stacia Miller Photography Collection); Wanda Yost Miller, for her classic 1950s photo; Paul Hutter, for his family store photos and the B&O train wreck; Nadeane Gordon, for the use of her collection of Cumberland photos; and Lee Schwartz and Gayle Griffith, the Book Center and B'er Chayim Temple (photographs and information on the Jewish Community in Cumberland). Also, thanks to Samuel J. White for assisting me with the proofing of the content.

A special thanks goes to Thomas J. Robertson for approaching me with the idea of producing this book. I would also like to thank all the behind-the-scenes people who helped in the formulation of the book.

This pictorial history of Cumberland was comprised of first-person documents and oral histories, along with the reference books listed below. The history that has been presented comes from information that has been researched and the photos are labeled to the best of my knowledge. I hope you enjoy this look into Cumberland's history.

REFERENCES

Alfred Feldstein. *Felstein's Historic Postcard Album of Allegany County, Maryland.* Cumberland, MD: Commercial Press Printing Company, 1983.

Alfred Feldstein. *Feldstein's Illustrated Tour Guide to Historic Sites in Allegany County, Maryland.* Cumberland, MD: Commercial Press Printing Company, 1993.

Stegmaier, Harry Jr., Dean, David, Kershaw, Gordon, and John Wiseman. *Allegany County: A History.* Parson, WV: McClain Printing Company, 1976.

INTRODUCTION

The location of Cumberland was known to early settlers of this country since the early 1700s. The earliest known map of the region was produced in 1751, but we know that settlers such as the Cresaps purchased land in the region as early as the 1730s. The town began as a trading post, started by Christopher Gist of the Ohio Company, between trappers and the Native Americans that traversed throughout this region of the Allegheny Mountains. In 1754, a fort was built on the banks of Wills Creek and the Potomac River. The fort was named after the Duke of Cumberland, son of King George II of Britain, and was a British supply and recruitment outpost during the French and Indian War. The town did not officially become city until 1789, when it became the county seat for the newly formed Allegany County, Maryland.

Cumberland has been a stopping point for many famous historical figures throughout its history. The most famous historical figure was Gen. George Washington. Washington actually visited several times throughout his life—first, when he was a young surveyor for Lord Fairfax, and several times when he was the Colonial Commander of the British Army. Finally, when he was President of the United States, he stopped to review the troops as he made his way to Pennsylvania during the Whiskey Rebellion.

Since Washington had so much influence on the area many felt that the town should be named Washingtontown, but travelers knew the area as Fort Cumberland. During the area's development as the county seat the forefathers of the town decided to officially name the town Cumberland. Yet, after the big industrial and population boom in the early 1900s some referred to Cumberland as the Queen City.

As early as the 1750s Cumberland was a transportation hub for the region. The Native Americans had various trails that early settlers and trappers used to travel through the mass wilderness of the area. During the French and Indian War, Gen. Edward Braddock built one of the first roads through the mountains on his way to Fort Duquense in 1755. Later, in 1813, the trail was used as the path for the National Road, the first federally funded road in the nation, which began in Cumberland and ended in Vandalia, Illinois.

Once roads were built to Cumberland, other transportation venues started searching for real estate in the area. In 1842, the first Baltimore & Ohio Railroad engine pulled into Cumberland. In 1850, the first canal boat floated into town on the Chesapeake & Ohio Canal. After these two transportation landmarks arrived, several trunk-line railroads started hauling freight and people to and from Cumberland.

The prosperity of Cumberland has been tied to the transportation industry that made its way into town. Since there were various means for transporting goods, factories began to spring up in and around the boundaries of Cumberland. At one time, Cumberland was home to the Kelly Springfield Tire Company, Celanese Fiber Company, three glass factories, two breweries, and many other factories. From this boom in transportation and industrial work, Cumberland became the second largest city in Maryland behind Baltimore. It was known as the "Queen City of Maryland."

During the Civil War, Cumberland was very important to the Union because of the railroads, the canal, and the coal found in the area. The city was protected from an invasion from the Confederate army by over 3,000 Union troops. After the Civil War, Cumberland's wealth was apparent by the building boom of large homes on Washington Street. Artists like Louis Comfort Tiffany were commissioned to design and construct elaborate stained glass windows for churches and private residences. This building expansion continued through the mid-20th century.

The glory of Cumberland can still be seen today in the beautiful historic districts, the Baltimore Street shopping district, and the phenomenal view of the church steeples at night. Its railroad heritage is still strong with the CSX engine school and repair shops. CSX's mainline still travels through town and a scenic railroad operates seasonally on the former Western Maryland Railway. Locals and visitors alike hike and bike along the C&O Canal Towpath. People enjoy music on Sunday summer evenings in Constitution Park. The city is springing with art and historic museums.

Even as Interstate 68 winds its way through the center of town, one can still feel as if they have stepped back in time. Historical buildings are being revitalized into wonderful shops, restaurants, and businesses. Generations new and old call Cumberland home.

One
EARLY CUMBERLAND

The settlement of Cumberland actually began as a trading post for trappers at the forks of the Potomac River and Wills Creek. The post was a seasonal meeting place for the isolated trappers and early settlers that lived and hunted in the surrounding area. Large gatherings of settlers and trappers came to the area to buy supplies and trade furs at least twice a year.

The seasonal gatherings were also important to the isolated people because it gave them a chance to learn about news that had happened over the past months. They would pass on mail and personal information, such as wanting to buy or sell land.

Finally, a group that was surveying for the Ohio Company documented Cumberland on a map in 1751. They were surveying the western region of Maryland, Pennsylvania, and Virginia (what is now West Virginia). This trading post was an important area on this map because of the annual meetings. Cumberland began as a destination when the Native American trails were being used by early explorers and trappers.

At the age of 16, George Washington made his way to Cumberland while surveying land for Lord Fairfax. He passed through the area for his first time while he was searching for the headwaters of the Potomac River. The headwater of the river was an important land boundary for Fairfax's parcel of land. King George II of England had granted the land, what is now West Virginia, to Fairfax. George Washington, later in his life, spent much of his time in Cumberland after the French and Indian War began in 1754 and Fort Cumberland was erected. Washington became a soldier in the colonial army and became a colonel after the sudden demise of Gen. Edward Braddock in 1755.

Fort Cumberland put the Cumberland area in the minds of the colonial world. Then, the city grew up around the remnants of the fort. The business district developed at the foot of the hill, where the fort once stood, and residential homes and many churches spread around the fort site.

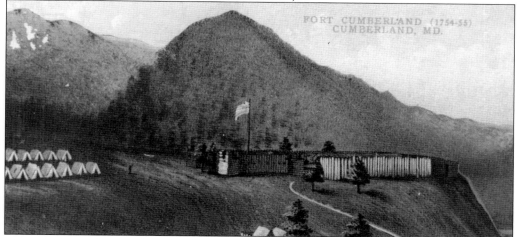

AN ARTISTIC DRAWING OF FORT CUMBERLAND. The fort was built as a supply and recruitment outpost in 1754–1755. It was originally named Fort Mt. Pleasant, but the name was soon changed to Fort Cumberland, to give recognition to the King of England's son, the Duke of Cumberland. (Courtesy of Allegany College of Maryland Library.)

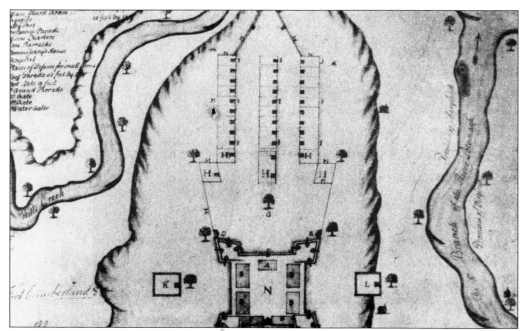

BLUE PRINT OF FORT CUMBERLAND. The plan outlines the construction of the barracks, stockade, and out buildings for the fort. The fort was built with wood that was harvested from the vast forests that surrounded the region at the time. (Courtesy of Allegany College of Maryland Library.)

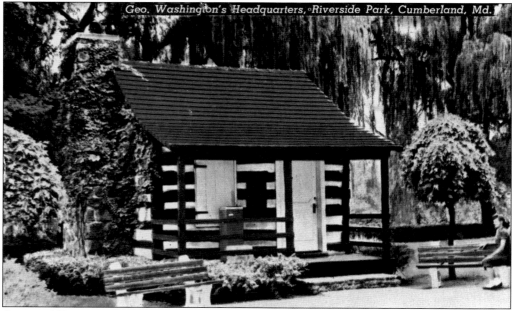

Geo. Washington's Headquarters, Riverside Park, Cumberland, Md.

GEORGE WASHINGTON'S HEADQUARTERS, THE ONLY REMAINING STRUCTURE FROM FORT CUMBERLAND. The first command of Col. George Washington was held at Fort Cumberland. As the commander of the Virginia military forces, he had his headquarters in Cumberland for several months. (Courtesy of Allegany College of Maryland Library.)

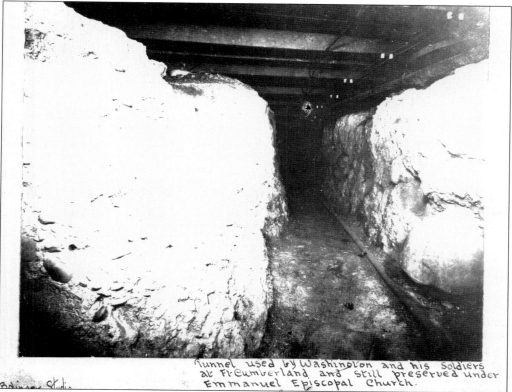

Tunnel used by Washington and his soldiers at Ft Cumberland and still preserved under Emmanuel Episcopal Church.

TUNNELS USED IN FORT CUMBERLAND DURING THE FRENCH AND INDIAN WAR. The soldiers that served Fort Cumberland built the tunnels and trenches. The tunnels were built to protect the soldiers from Native American and French bullet and arrow fire as they traveled to the river and creek banks. The tunnels and trenches lead from the fort walls to the men's water supply, the Potomac River and Wills Creek. (From the Herman and Stacia Miller Collection, courtesy of the Mayor and City Council of Cumberland, Maryland.)

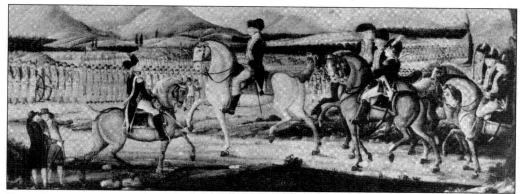

FORT CUMBERLAND, IN USE EVEN AFTER THE FRENCH AND INDIAN WAR ENDED IN 1763. In 1794, President George Washington reviewed his troops as the Commander and Chief of the newly developed United States of America. The troops gathered here to follow the military that had been formed to suppress the Whiskey Rebellion in nearby Pennsylvania. Washington began and ended his military career in Cumberland. (Courtesy of Nadeane Gordon.)

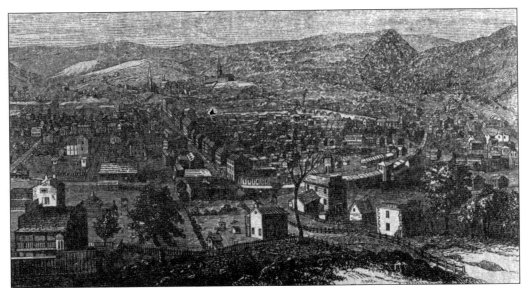

DRAWING OF CUMBERLAND, 1855. This sketch depicts the south side of Cumberland. It illustrates how the city was a small self-sufficient town. The houses have large plots with gardens and out buildings. Shortly after the 1850s the town became a service city developing products for consumer use. (Courtesy of Allegany College of Maryland Library.)

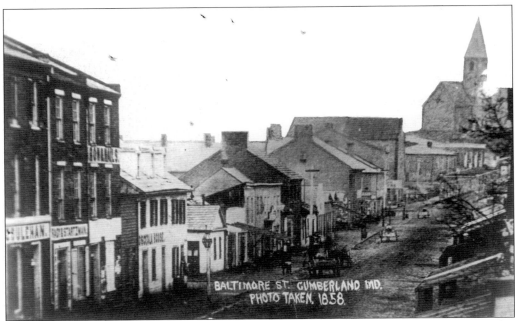

BALTIMORE STREET, 1858. The business district of Baltimore Street started to increase after the Baltimore & Ohio Railroad and the Chesapeake & Ohio Canal made their way into Cumberland. One could find dry goods, produce, and other services along this street. (Courtesy of Allegany County Historical Society.)

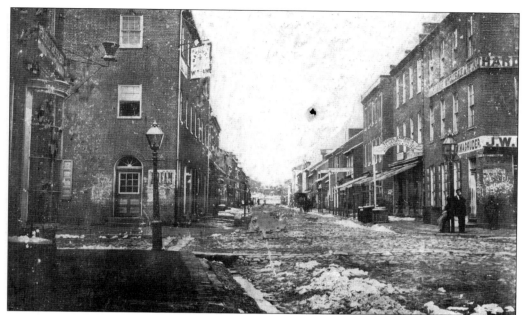

BALTIMORE AND MECHANIC STREETS, 1857. The sidewalks are complete and lamp posts have been installed. Businesses have expanded into reliable stores. (Courtesy of Allegany County Historical Society.)

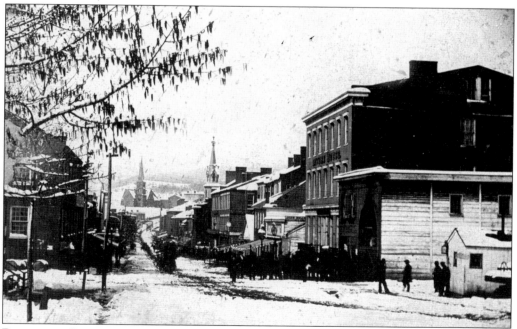

BALTIMORE STREET FROM THE B&O RAILROAD CROSSING, 1857. Winter weather and messy streets did not keep shoppers away from Baltimore Street. Most customers walked to the stores and businesses in the winter months because the streets were not always cleared. It was the responsibility of the merchants to clear the snow out of the streets and sidewalks at the time. (Courtesy of Allegany County Historical Society.)

LATE 1850s VIEW OF GREENE STREET. This section of Cumberland was one of the first to be settled because it is the near grounds where Fort Cumberland stood and where the Emmanuel Episcopal Church stands. Prior to the fort, a trading post for trappers was located in this area. Greene Street was one of the first streets to be surveyed for development of a city street. (Courtesy of Allegany County Historical Society.)

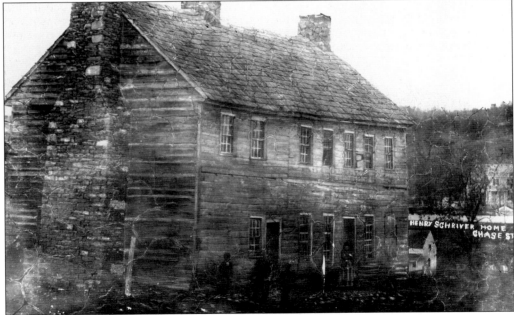

FAW TAVERN. This tavern is a great example of what many of the homes looked liked in the early development of Cumberland. A majority of the houses and businesses were wooden and most were destroyed by fires. There are not many buildings remaining in Cumberland from this time, as they either burnt down or were torn down for new development. (Courtesy of Allegany College of Maryland Library.)

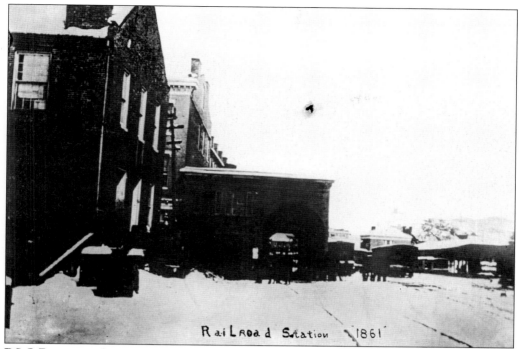

R ai L Road Station 1861

B&O RAILROAD STATION, 1861. This station was built shortly after the railroad made its way to Cumberland and defined the city as a service city. When the railroad pulled into Cumberland in 1842, it brought goods to the city, and farmers and merchants shipped items on the railroad to be sold in the east. The railroad was a main vein to Cumberland and became a major employer and people-mover. (Courtesy of Allegany College of Maryland Library.)

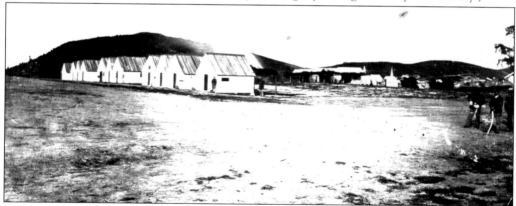

FORT HILL UNION ARMY ENCAMPMENT, 1863. Cumberland's history is full of military encampments; the town played a part in the French and Indian War, the Revolutionary War, the Whiskey Rebellion, and the Civil War. This is a picture of the Union Army of the Potomac encampment. During the Civil War, the Union Army had over 3,000 troops stationed here to protect the transportation lines of the B&O Railroad and the C&O Canal. In addition to the importance of the transportation in Cumberland was the coal that was being mined in the Georges Creek Valley. It was of great importance to the U.S. government, especially since our coal supplied power for the advanced naval steam-powered ships. (From the Herman and Stacia Miller Collection, courtesy of the Mayor and City Council of Cumberland, Maryland.)

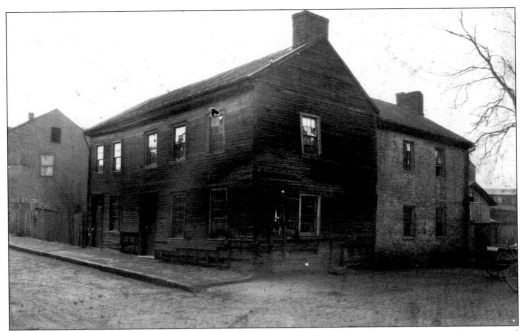

NORTH END OF MECHANIC STREET. This area of the city was known as the factory and warehouse district. Once city growth began, the industrial revolution was in full swing and factories that produced glass, milled flour, and brewed beer sprang up in the north end. This building was one of the residences that housed several workers. Most of these dwellings burned down when one of the glass factories caught fire. (From the Herman and Stacia Miller Collection, courtesy of the Mayor and City Council of Cumberland, Maryland.)

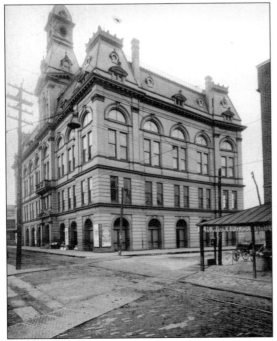

THE MUSIC ACADEMY/ CITY HALL. This is the city's second city hall. The first city hall burned down in the early 1840s. This was not the usual city government building; its main purpose was to be used as a diversified entertainment hall. It opened its doors in 1876 and was very popular since it was one of the most modern theatres between Baltimore and Pittsburgh. The Academy of Music was destroyed by fire in 1910. (Courtesy of Nadeane Gordon.)

Two
THE QUEEN CITY

Cumberland's population and economic boom lasted a little more than half of a century, from 1865 to 1940. The transportation industry had the greatest economic impact on the growth of the city. Once the B&O Railroad steamed into Cumberland in November of 1842, the growth of industry began. Finally, there was an easy link to the vast population of the East Coast and a means to transport goods to market. This economic growth expanded once the C&O Canal reached Cumberland in October 1850. There were now two means of transport to choose from to haul goods to the buyers in the East. This growth was delayed once the Civil War broke out, but after the signing at Appomattox, Cumberland grew into the Queen of the state of Maryland. Industry exploded and the population grew to make Cumberland the second largest city in Maryland behind Baltimore.

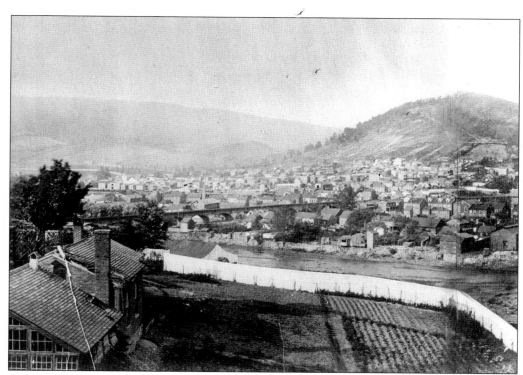

WEST SIDE OF CUMBERLAND, TAKEN FROM WEST VIRGINIA, 1880. The city has grown up to the banks of Wills Creek. It looks almost as if it is ready to bust at the seams. In the distance, development is sprawling up the mountainsides of Wills and Haystack Mountains. (Courtesy of Allegany County Historical Society.)

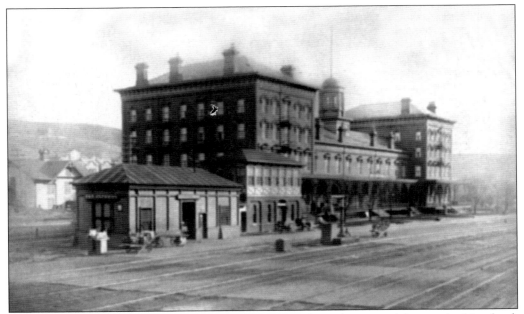

QUEEN CITY HOTEL. Once the population increased to the second largest in Maryland, Cumberland would always be known as the Queen City. The B&O Railroad built a hotel named for the Queen City in 1872. It featured marble fireplaces, a ballroom, and a plush dining room. Trains would stop to allow passengers time to enjoy dinner as they passed through or to stay overnight to experience this enormous station. (Courtesy of Nadeane Gordon.)

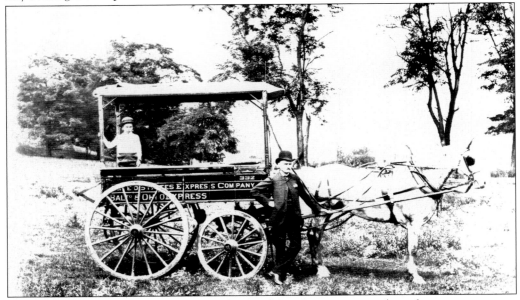

B&O DELIVERY WAGON. The B&O Railroad tried to accommodate their passengers as much as possible. In Cumberland, like many cities that the B&O traveled through, they had a service to pick up or deliver goods from the railroad. Many times these wagons would also be used as cabs. These services always came with a price tag. (From the Herman and Stacia Miller Collection, courtesy of the Mayor and City Council of Cumberland, Maryland.)

NEW BUILDINGS ON BALTIMORE STREET. A fire in 1893 brought new buildings to the streets of Cumberland. The fire destroyed the wood-sided frame buildings. With the population and economic growth high, the merchants could now afford to rebuild their businesses and use stone and brick instead of the wooden-framed structures. (From the Herman and Stacia Miller Collection, courtesy of the Mayor and City Council of Cumberland, Maryland.)

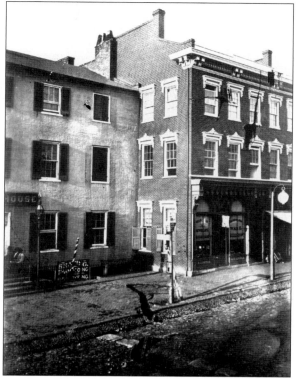

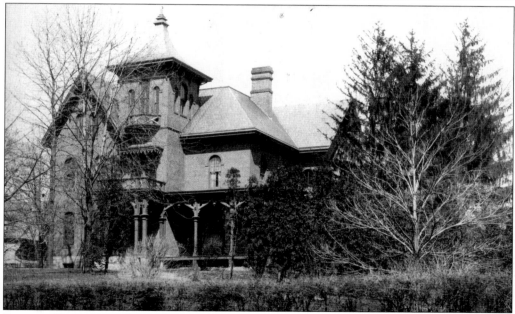

ROMAN RESIDENCE. Large homes like this one became common on the west side of Cumberland. Along Washington Street and paralleling streets (Lee, Smallwood, and Cumberland), Victorian inspired architecture was built by wealthy merchants, canal presidents, and dam builders. (Courtesy of Nadeane Gordon.)

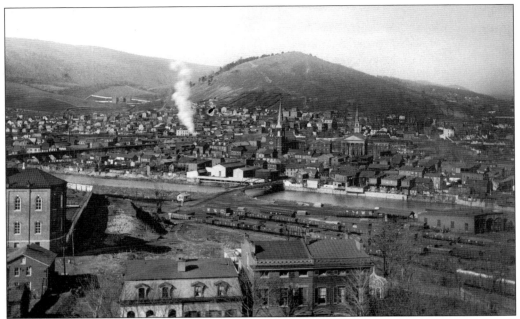

PANORAMIC VIEW OF CUMBERLAND'S WEST SIDE, 1890. Cumberland's distinctive church steeples rise from the hillsides of the city. St. Peter's Catholic Church, center, and St. Patrick's Catholic Church, behind what is known today as the Main Branch of the Allegany County Library, are shown in this photograph. (Courtesy of Nadeane Gordon.)

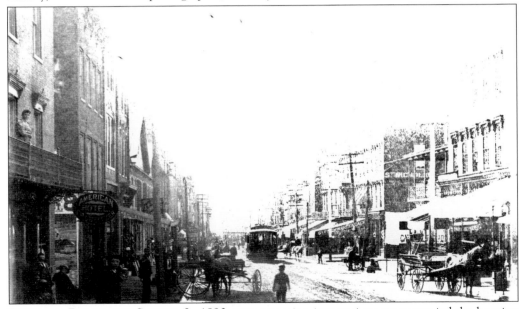

BUSTLING BALTIMORE STREET. In 1890, transportation innovations accompanied the housing boom of Cumberland. Cumberland Electric Railway Line started running trolleys from Cumberland to Narrows Park in LaVale. Opening in June of 1891, it cost a nickel to ride the trolley from the center of town to the Narrows. (From the Herman and Stacia Miller Collection, courtesy of the Mayor and the City Council of Cumberland, Maryland.)

Building of the Allegany County Courthouse. This structure is the third courthouse built for Allegany County; the prior two were destroyed by fire. The building was constructed from 1893 to 1894 and was patterned after the Allegheny County Courthouse in Pittsburgh, Pennsylvania. (From the Herman and Stacia Miller Collection, courtesy of the Mayor and City Council of Cumberland, Maryland.)

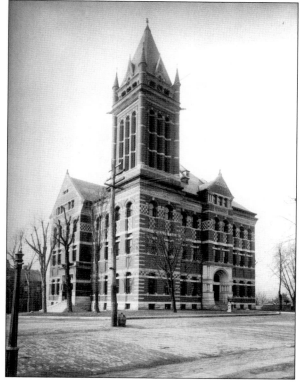

Completed Allegany County Courthouse. Wright Butler, a local architect, built the courthouse in the Richardson's Romanesque style. The courthouse has been in use for almost 110 years and has become a local fixture to Cumberland's historic district. (Courtesy of Nadeane Gordon.)

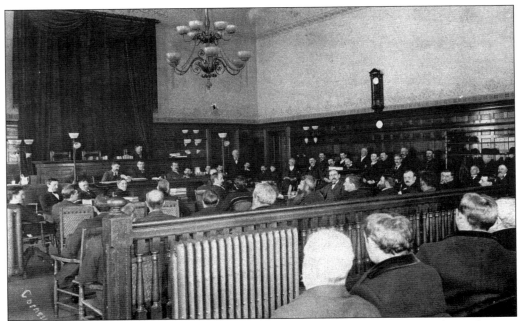

INTERIOR OF COURTHOUSE, 1896. The interior of the courtroom, as shown above, has not changed since this picture was taken in 1896. The building is still almost intact to the original plans. (Courtesy of Allegany College of Maryland Library.)

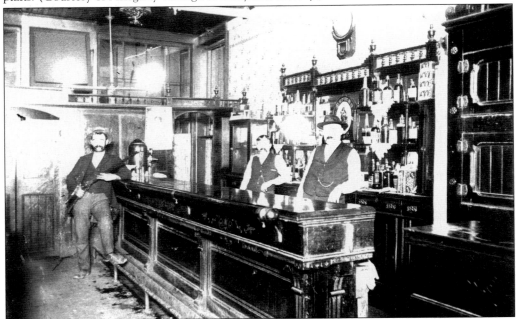

LOCAL BAR SCENE. Even though Cumberland was going through a building and economic boom, this did not mean it was going to lose its wild personality. Bars and gambling houses lined Wineow Street and it was common to see an armed man. The locals called this part of the city "Shantytown." (From the Herman and Stacia Miller Collection, courtesy of the Mayor and City Council of Cumberland, Maryland.)

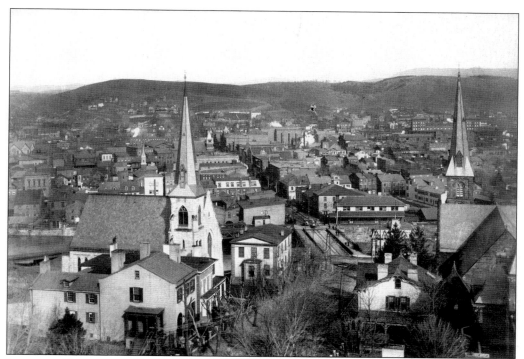

LOOKING EAST FROM COURT HOUSE. The streets of Cumberland are full of urban growth. Buildings are back to back. (Courtesy of Nadeane Gordon.)

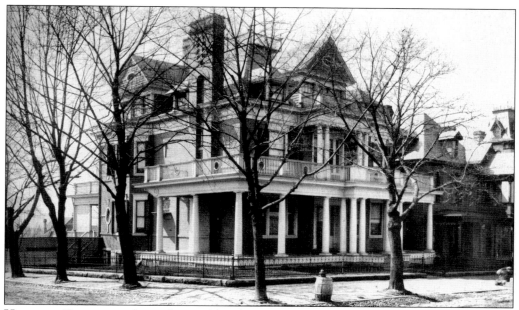

HUMBRID RESIDENCE. Large homes like this one indicate the large amount of wealth that Cumberland residents had. Homes such as this were widely built during the Gilded Age (1870–1920). (Courtesy of the Nadeane Gordon.)

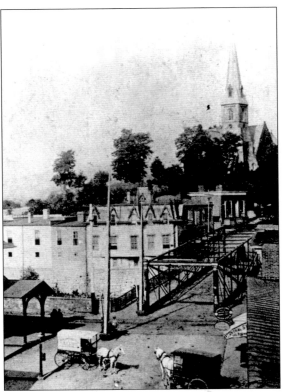

BRIDGE AT WILLS CREEK, BALTIMORE STREET. Merchant delivery wagons were an everyday scene. They had regular deliveries to the large homes on Washington Street. The west side of Cumberland has always been known for its upper-class dwellings. The houses of the wealthy were located after you crossed the iron bridge at Baltimore Street and went up the hill. (From the Herman and Stacia Miller Collection, courtesy of the Mayor and City Council of Cumberland, Maryland.)

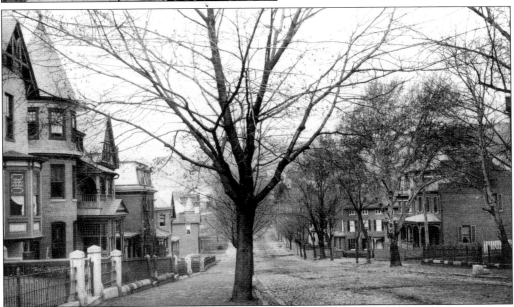

SCENE ALONG WASHINGTON STREET. Now known as the historic district, Washington Street is lined with large Victorian-style homes. Many of these homes have original Louis Comfort Tiffany glass in their windows and doors. A majority of the homes were built between 1853 and 1912. (Courtesy of Nadeane Gordon.)

Three
RAIL, ROADS, AND WATER

The area became a transportation hub in 1813, when the National Road cut its way through the wilderness west to Wheeling, Virginia (now West Virginia). Once the B&O steamed into town in 1842 and the first canal boat drifted into the western terminus of the C&O Canal in 1850, Cumberland became a transportation mecca. It was no longer viewed as a frontier town. Businesses and factories settled here for the convenience of shipping and receiving goods via rail, road, and canal.

Not only did Cumberland have the convenience of the B&O, it also had many trunk railroad lines serving the area. Most of these lines developed around the coal-mining industry in the George's Creek Valley, just west of Cumberland. Coal mining made the region thrive with workers, wealth, and trains.

The Cumberland and Pennsylvania Railroad (C&P) started in 1845. Its shop was in Mount Savage, serving the mines and people of Allegany County. In 1910, the Western Maryland Railway made its way into the area from Baltimore and became the B&O's major competitor. Other small lines like the Georges Creek and Cumberland Railroad had a place in Cumberland's vast system by 1884.

Other transportation systems, like the stagecoaches on National Road, which traveled daily on the road from Baltimore to Wheeling, also passed through Cumberland. Cumberland became a popular stop for the coaches before they completed their trip west. One could purchase a ticket for a stagecoach heading east or west on the corner of Centre and Hanover Streets (where the Corner Tavern is today).

The railroad trunk lines used the C&O Canal as a means to transport their goods to the east. The coal ended at a terminus where the C&P Railroad and the Georges Creek and Cumberland Railroad lines ended and dumped coal into the canal boats. The trunk lines would often pick up goods from the east and deliver them to the depots to the west.

With the invention of electricity came the Cumberland Electric Railway in 1891. The trolley line was built after Cumberland real estate expanded to both the south and north ends of the city. The trolley line traveled from the center of the city to Narrows Park just outside of the city limits. The line then extended tracks to South Cumberland and also expanded west to George's Creek Electric Railway line.

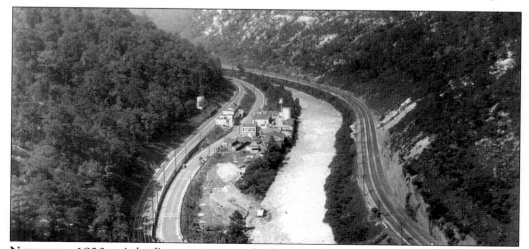

NARROWS, 1930S. A bird's eye view reveals the natural cut between Wills Mountain and Haystack Mountain. The National Road, the Western Maryland Railway, the B&O Railway, and the Cumberland Electric Railway all used this as a means to travel east to west.

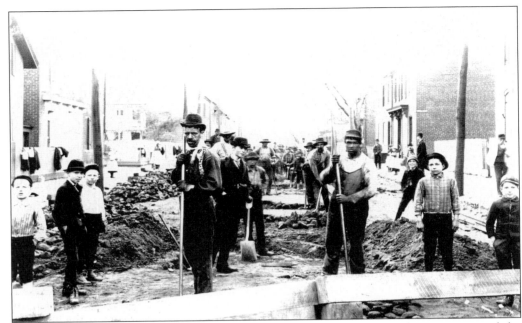

THE NATIONAL ROAD. A group of men pose for a photo as they surface a portion of the National Road. There are no original pictures of the first attempt at constructing the road, but they used the same method that is seen in this shot. The workers started by leveling the surface of the road and placed large rocks down as a base. Then, smaller rocks were added to fill in the holes; this process was repeated until all of the holes were filled. Sand and shale were placed on top to fill in the cracks between the rocks. (From the Herman and Stacia Miller Collection, courtesy of the Mayor and City Council of Cumberland, Maryland.)

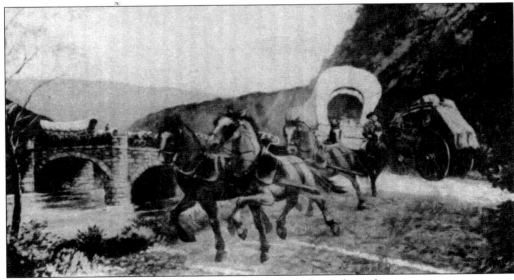

TRAFFIC ON THE NATIONAL ROAD. The National Road was the only major route east to west for years and this caused many traffic jams along the route. This is a drawing of a bridge over Wills Creek in the Narrows. (Courtesy of Allegany College of Maryland Library.)

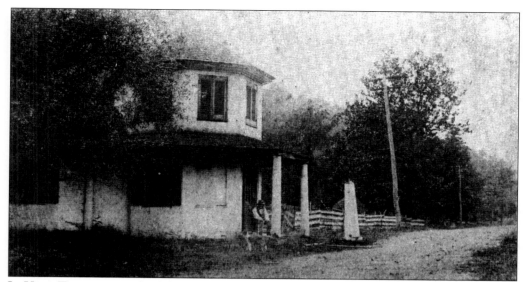

LaVale Tollhouse. The federal government paid for the National Road to be built, but after the road was completed in each of the six states it passed through, it was up to each state to maintain the road. LaVale is the location of the first tollhouse that was built on the National Road in 1836. (Courtesy of Allegany College of Maryland Library.)

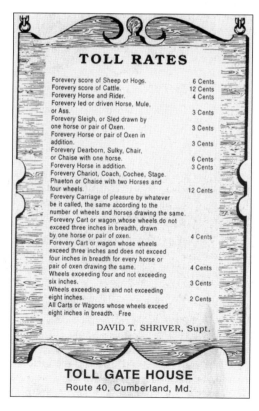

TOLL RATES

Forevery score of Sheep or Hogs.	6 Cents
Forevery score of Cattle.	12 Cents
Forevery Horse and Rider.	4 Cents
Forevery led or driven Horse, Mule, or Ass.	3 Cents
Forevery Sleigh, or Sled drawn by one horse or pair of Oxen.	3 Cents
Forevery Horse or pair of Oxen in addition.	3 Cents
Forevery Dearborn, Sulky, Chair, or Chaise with one horse.	6 Cents
Forevery Horse in addition.	3 Cents
Forevery Chariot, Coach, Cochee, Stage. Phaeton or Chaise with two Horses and four wheels.	12 Cents
Forevery Carriage of pleasure by whatever be it called, the same according to the number of wheels and horses drawing the same.	
Forevery Cart or wagon whose wheels do not exceed three inches in breadth, drawn by one horse or pair of oxen.	4 Cents
Forevery Cart or wagon whose wheels exceed three inches and does not exceed four inches in breadth for every horse or pair of oxen drawing the same.	4 Cents
Wheels exceeding four and not exceeding six inches.	3 Cents
Wheels exceeding six and not exceeding eight inches.	2 Cents
All Carts or Wagons whose wheels exceed eight inches in breadth. Free	

DAVID T. SHRIVER, Supt.

TOLL GATE HOUSE
Route 40, Cumberland, Md.

Toll Rates. Travelers were charged for anything from the width of their wagon wheel to how many animals were traveling with them. After the mass train systems spread across the United States, the use of the road slackened to only local traffic until the invention of the automobile. (Courtesy of Allegany College of Maryland Library.)

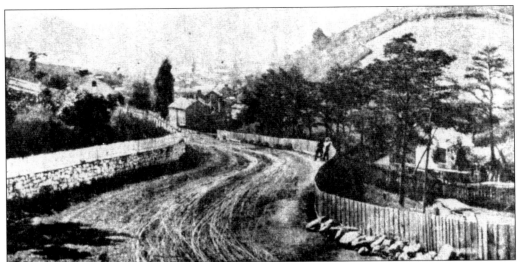

THE BALTIMORE PIKE LEADING INTO CUMBERLAND. This is a good view of what the National Road looked like once it was completed. Many towns developed as the National Road made its way west. Inns and taverns were built along the road to accommodate travelers. (Courtesy of Allegany College of Maryland Library.)

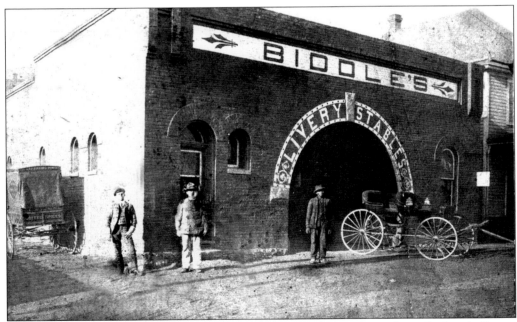

BIDDLE'S LIVERY. Businesses like Biddle's Livery, which was located on Frederick Street, thrived once the National Road made its way west to Wheeling. Travelers, wagoneers, and stagecoach drivers could rest and feed their horses, or purchase a new horse at Biddle's. It was also a cab company, where local residents could hire a horse or carriage. (From the Herman and Stacia Miller Collection, courtesy of the Mayor and City Council of Cumberland, Maryland.)

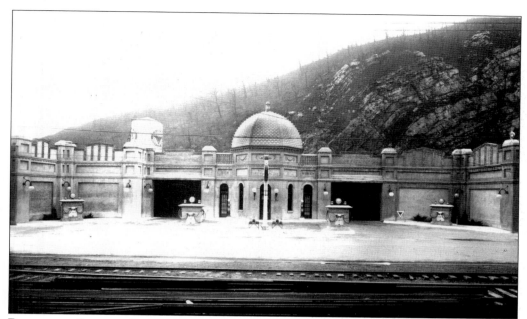

Byzantine Service Station, the Narrows. Once the automobile became popular, the National Road saw a resurgence of traffic. Service stations popped up along the road just as inns and taverns had done a century before. This was an elaborate service station, built in 1919, that stood in the Narrows until in burned down in the mid-20th century. (From the Herman and Stacia Miller Collection, courtesy of the Mayor and City Council of Cumberland, Maryland.)

Bridge Across Wills Creek, 1920s. The National Road (portion of Baltimore Street, above) was very crowded in towns and cities like Cumberland. Travelers had to share the road with carriages, pedestrians, wagons, cars, and trolley lines. (Courtesy of Allegany College of Maryland Library.)

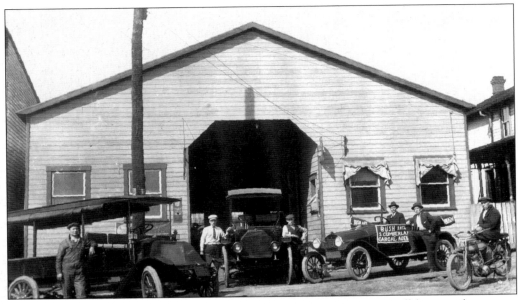

BUSH'S GARAGE. Located in south Cumberland, this auto garage was a well-known place to get your car or motorcycle fixed. Bush's was also a good place to catch up on the gossip that was circulating through town. (Courtesy of Allegany County Historical Society.)

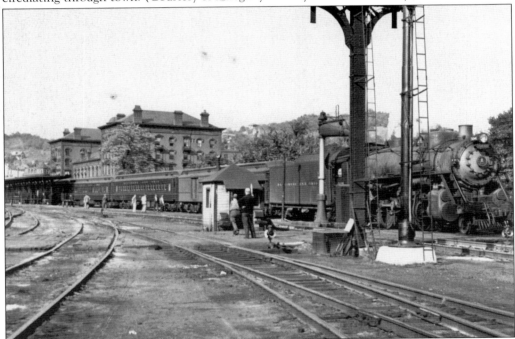

B&O PASSENGER TRAIN. Once the B&O pulled into Cumberland in November 1842, the city became a railroad town. People in the west finally had an easy route to travel that would not take days on the rough and primitive roads. The railroad was a god-send for merchants and businesses as they could receive and send items via the railroad. (From the Herman and Stacia Miller Collection, courtesy of the Mayor and City Council of Cumberland, Maryland.)

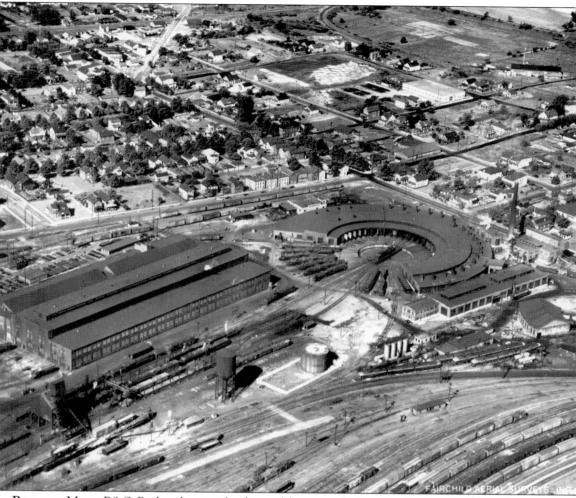

ROLLING MILL. B&O Railroad not only changed how people lived in Cumberland, but also Cumberland's appearance. The B&O owned much of the land on the edge of the city—thirty acres to be exact. The rolling mill was completed in 1870 and employed 750 men, who turned out 2,500 tons of steel rails every month for the railroad. Cumberland lived and breathed on the railroad because it supplied the city and employed so many. (From the Herman and Stacia Miller Collection, courtesy of the Mayor and City Council of Cumberland, Maryland.)

STEAMY CUMBERLAND. After the B&O came to Cumberland, other railroads soon pulled into town. At one time there were five different railroads using Cumberland as a stop. (From the Herman and Stacia Miller Collection, courtesy of the Mayor and City Council of Cumberland, Maryland.)

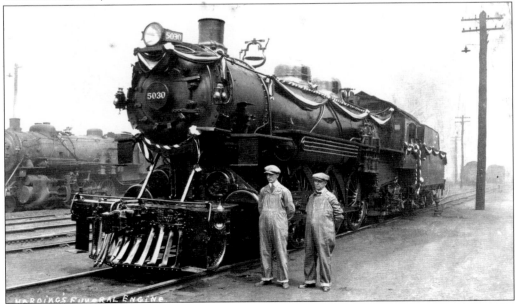

FUNERAL ENGINE. The railroad was not only a part of life in Cumberland, but also a part of death. President Harding's funeral train traveled through Cumberland in the 1920s. (From the Herman and Stacia Miller Collection, courtesy of the Mayor and City Council of Cumberland, Maryland.)

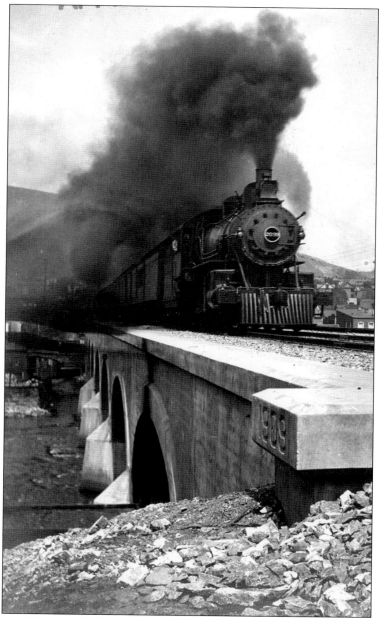

B&O STEAM ON VIADUCT. This train is traveling over a 13-span viaduct that was built in 1909 to accommodate the Grafton, West Virginia, mainline. The viaduct is still used today by CSX mainline. (Courtesy of Allegany College of Maryland Library.)

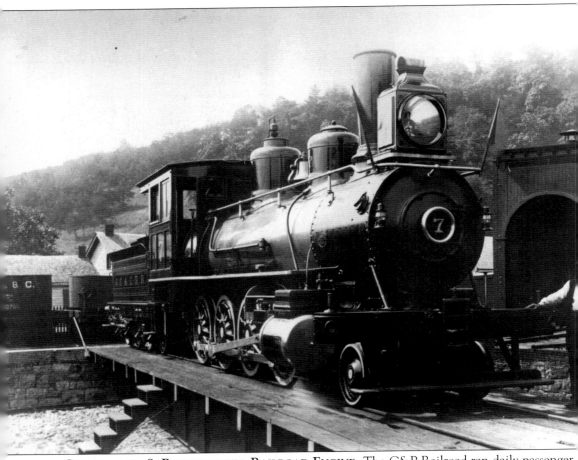

CUMBERLAND & PENNSYLVANIA RAILROAD ENGINE. The C&P Railroad ran daily passenger and freight trains from the George Creek and Jennings Run Valleys. The railroad was a trunk line that also hauled goods to local depots in outlying communities. The railroad started in 1845 and went bankrupt shortly after the Great Depression began. (From the Herman and Stacia Miller Collection, courtesy of the Mayor and City Council of Cumberland, Maryland.).

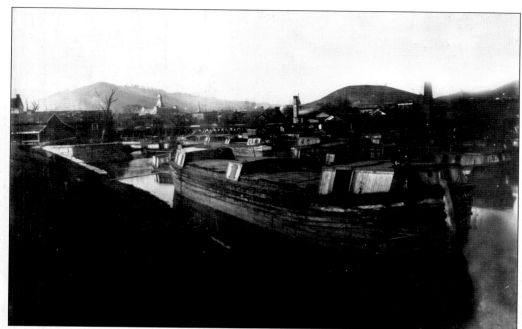

CANAL BOATS OUTSIDE OF CUMBERLAND, CHESAPEAKE & OHIO CANAL. Cumberland became the western terminus of the C&O Canal in 1850. It took 32 years for the canal to be built from Georgetown in Washington, D.C., to Cumberland, Maryland. Once the canal arrived in Cumberland it became a vein in the transportation body. Working on the canal was a way of life. Many canal boat captains lived on their boats with their families year-round and the whole family worked on the boat. The families would not only have to share living quarters with the cargo that they were hauling, but also black snakes, which were welcomed on the boat to keep the rats and mice at bay. The mule would also be welcomed aboard depending on the weather and the location where they were stopping for the night. (From the Herman and Stacia Miller Collection, courtesy of the Mayor and City Council of Cumberland, Maryland.)

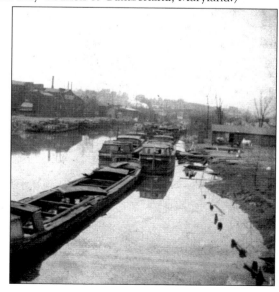

CANAL BOAT YARD. Cumberland was also home to a canal boat yard. This photo shows an incomplete canal boat near Wineow Street. (From the Herman and Stacia Miller Collection, courtesy of the Mayor and City Council of Cumberland, Maryland.)

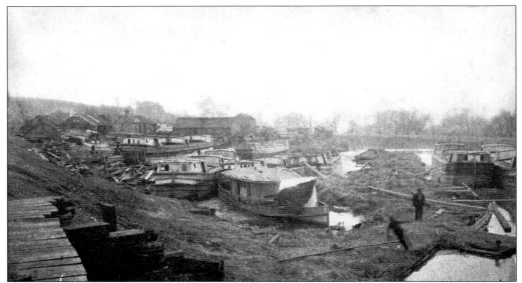

END OF THE LINE. Many times the owners of the canal boats purchased a boat for a couple of trips to haul goods and, when they were finished hauling or they had had their fill of canal life, they would tear the boat apart and use or sell the lumber. Remnants of boats can be seen on the banks of the canal near the Footer Dye Works building in this photo. (From the Herman and Stacia Miller Collection, courtesy of the Mayor and City Council of Cumberland, Maryland.)

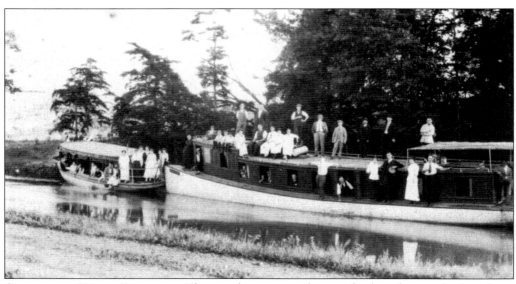

CANALLING, WHAT PLEASURE. The canal was not only a work place for people, but also a place for pleasure rides. People would have parties on canal boats and enjoy summer days lazily floating along. (From the Herman and Stacia Miller Collection, courtesy of the Mayor and City Council of Cumberland, Maryland.)

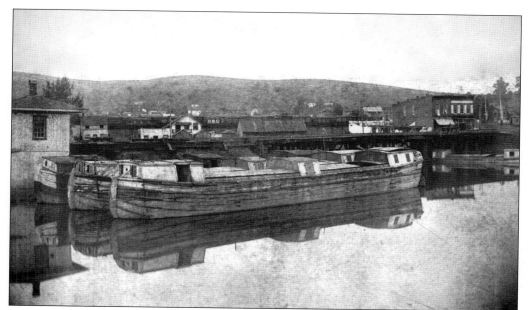

RESTING A WHILE. The Western Terminus of the canal was a resting-place for the crews of the canal boats. They had time to check out the sites and scenes of Cumberland before traveling back east. Many boats filled up at the loading wharf of the terminus for the return trip east. The canal boats would float under the railroad track and the trains would dump tons of coal into the boats. (From the Herman and Stacia Miller Collection, courtesy of the Mayor and City Council of Cumberland, Maryland.)

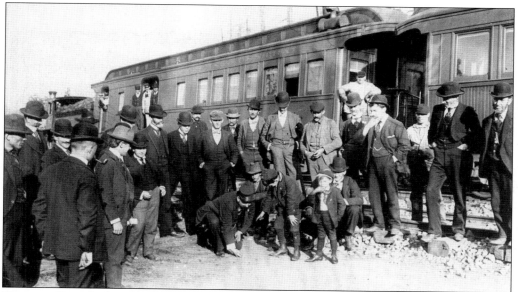

OPENING DAY. In late June 1891, the Cumberland Electric Railway started running from the center of Cumberland to Narrows Park in LaVale. Many people thought that the trolley line would never work because walking was free and it cost a nickel to ride the trolley. (From the Herman and Stacia Miller Collection, courtesy of the Mayor and City Council of Cumberland, Maryland.)

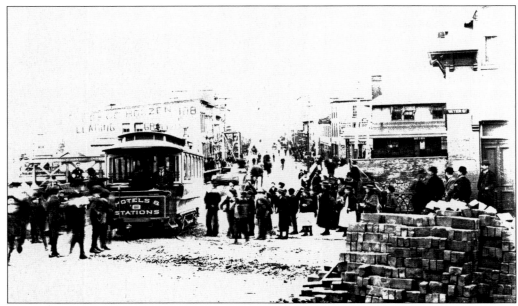

TROLLEY AT BALTIMORE & GREENE STREET. It seems the trolley line proved the pessimists wrong; look at how busy the trolley was at this intersection. (From the Herman and Stacia Miller Collection, courtesy of the Mayor and City Council of Cumberland, Maryland.)

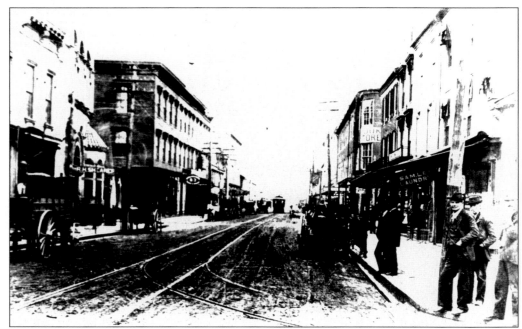

CENTER OF TOWN. The trolley line ran straight through the center of Cumberland. This photo gives you an idea about how busy the street traffic became on Baltimore Street. (From the Herman and Stacia Miller Collection, courtesy of the Mayor and City Council of Cumberland, Maryland.)

Taking a Turn. At the corner of Centre and Baltimore Streets the trolley takes a wide turn to begin another trip on the line. (From the Herman and Stacia Miller Collection, courtesy of the Mayor and City Council of Cumberland, Maryland.)

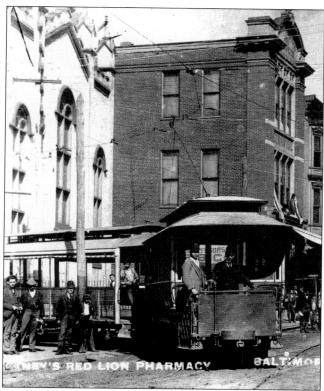

Central West Virginia Railway Bridge. This bridge crossed over the Potomac River from Ridgeley, West Virginia, to Cumberland. The Central West Virginia Railway was a short-lived trunk line that hauled goods into Cumberland. The Western Maryland Railway purchased the line. (Courtesy of Allegany County Historical Society.)

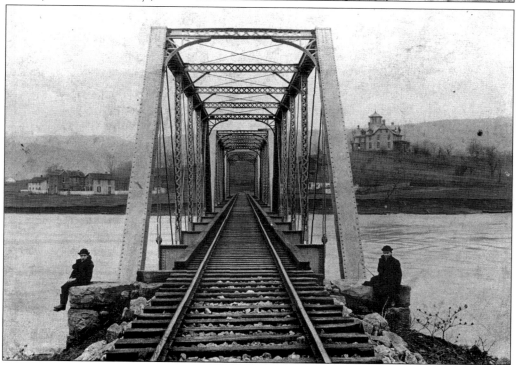

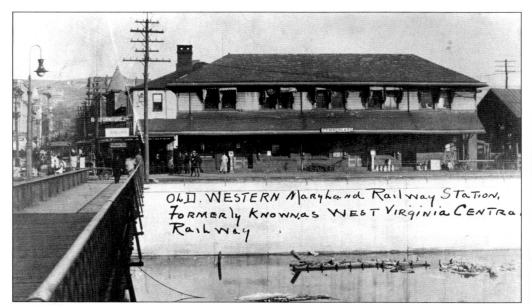

In the photograph, handwritten text reads:

OLD. WESTERN Maryland Railway STation,
Formerly Known as West Virginia CENTRa.
Railway

THE FIRST WESTERN MARYLAND RAILWAY STATION. When the Western Maryland Railway made its way into Cumberland in 1910, it took over the Central West Virginia Railway, which was built in 1887, and its building. This building was torn down three years later, when the Western Maryland Railway Station was completed. (Courtesy of Allegany County Historical Society.)

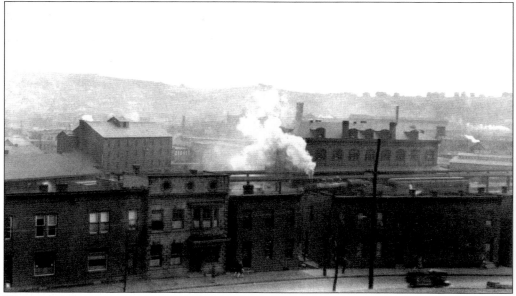

WESTERN MARYLAND RAILWAY STATION, 1913. This station was constructed from the same plan as all of the stations that the Western Maryland Railway built as they traveled west. All of the stations were four-floor structures. Baggage and local freight were received on the ground floor; tickets were purchased on the second floor, concourse area; the stationmaster and staff were on the third floor; and the finance offices were on the fourth floor. (From the Herman and Stacia Miller Collection, courtesy of the Mayor and City Council of Cumberland, Maryland.)

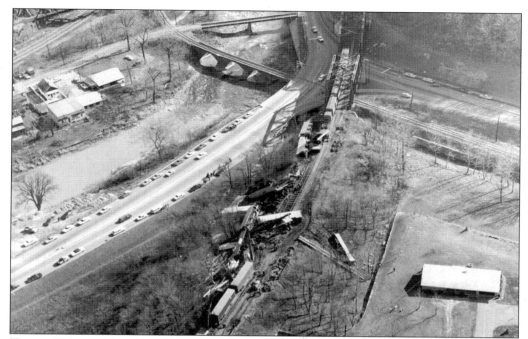

TRAIN WRECK. Not every day was a good day for the railroads in the Cumberland area. This is an aerial view of a Western Maryland Railway train wreck that occurred just past the double truss bridge at the intersection of Route 40 and Route 36 in the Narrows. (From the Herman and Stacia Miller Collection, courtesy of the Mayor and City Council of Cumberland, Maryland.)

SHRINERS' ENGINE. Shrine Clubs across America took advantage of the rails, too. This temple engine pulled through Cumberland in the late 1890s. Shriners manned the trains with their own crew of an engineer, a fireman, and a brakeman. (From the Herman and Stacia Miller Collection, courtesy of the Mayor and City Council of Cumberland, Maryland.)

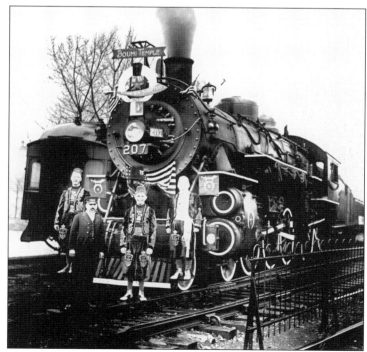

41

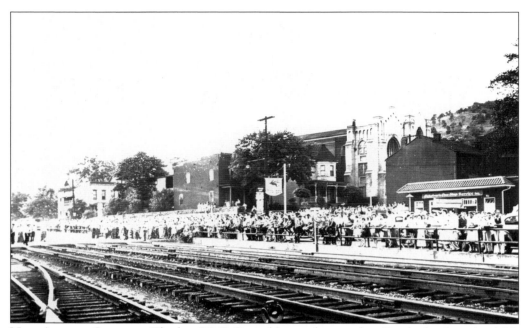

NEW AMTRAK STATION. The last B&O Capital Limited stopped in Cumberland on April 30, 1971. Soon after, the Queen City Station was torn down in 1975. The new Amtrak Station was built on Harrison Street in 1975 and the first Amtrak pulled into Cumberland in 1976.

Four
WHERE WE WORKED

When Cumberland became a large industry base for many businesses and industrial factories, the city boomed with economic wealth and population. There were jobs to be had everywhere, depending on your interests and skills. One could find a job in the transportation industry with one of the six railroads that worked in town, with the C&O Canal, with the Electric Railtrolley, or with livery stables (later service stations). There were also many jobs within the service industry among the many hotels, inns, and delivery businesses in the city. There were also glass factories, breweries, foundries, a tire plant, a fiber plant, brick making, iron works, etc.

Hardly anyone was unemployed in Cumberland for more than a day. The reason for Cumberland's growth was the transportation industry that could move goods to and from the large markets on the East Coast. The other reason industry and businesses grew in Cumberland and the surrounding area was the discovery of coal in the George's Creek Valley. The industries, railroads, and businesses used this coal for power.

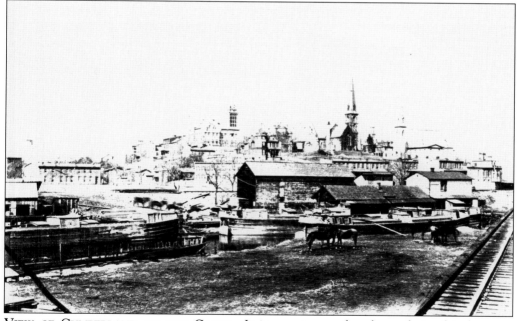

VIEW OF CUMBERLAND AT THE CANAL. It is easy to see the close relationship between industries and transportation in Cumberland. They were within steps of each other. The businesses and factories grew up along the railroad tracks and the canal basin. (From the Herman and Stacia Miller Collection, courtesy of the Mayor and City Council of Cumberland, Maryland.)

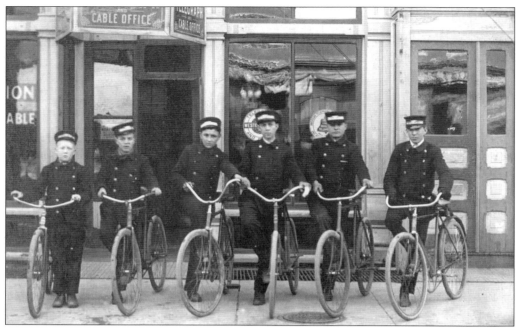

BIKE MESSENGERS. Bike messengers were seen daily on the streets of Cumberland. The local Western Union Telegraph Company and Cable Office employed these young men and boys in town. They would rush messages to recipients all over the city. (From the Herman and Stacia Miller Collection, courtesy of the Mayor and City Council of Cumberland, Maryland.)

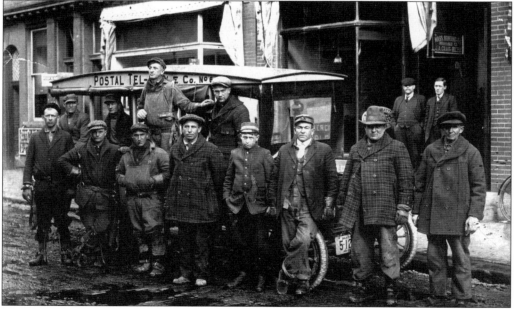

POSTAL SERVICE. The United States Postal Service on Liberty Street had a wiring service in addition to their mail service. These men were proud to work through rain, sleet, and snow to deliver peoples mail and packages in the city. (From the Herman and Stacia Miller Collection, courtesy of the Mayor and City Council of Cumberland, Maryland.)

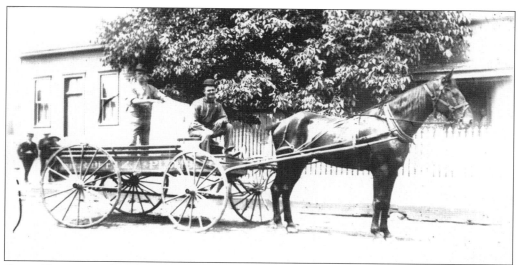

COOL DELIVERY. Another fast delivery in Cumberland was from the local icehouse. The company would deliver blocks of ice to homes, placing it directly into the family's icebox from a rear door in the back or side of the home. (From the Herman and Stacia Miller Collection, courtesy of the Mayor and City Council of Cumberland, Maryland.)

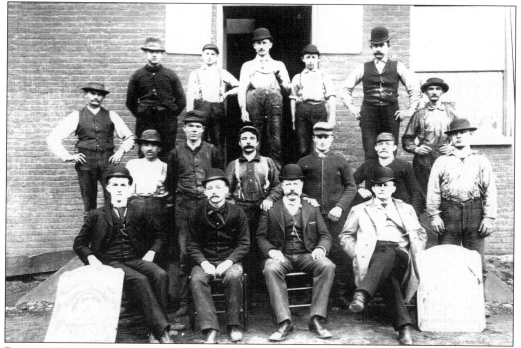

PROUD WORKERS. These Old German Brewing Company workers were proud to have their photograph taken outside of the plant building. The company changed its name to Liberty Brewing Company in 1917, during World War I, and in 1920 it changed its name again to Queen Brewing. This company was famous for making Old German Beer. (From the Herman and Stacia Miller Collection, courtesy of the Mayor and City Council of Cumberland, Maryland.)

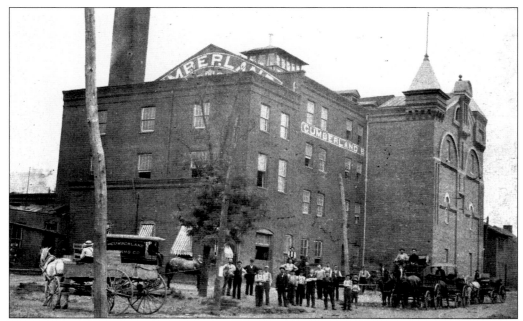

CUMBERLAND BREWING COMPANY. This brewery produced Old Export Beer and Gamecock Ale. Cumberland Brewing Company was the oldest brewery in Cumberland and was purchased by Queen City Brewing Company in 1958. It was the last surviving brewery in Cumberland before it closed its doors in 1976. (From the Herman and Stacia Miller Collection, courtesy of the Mayor and City Council of Cumberland, Maryland.)

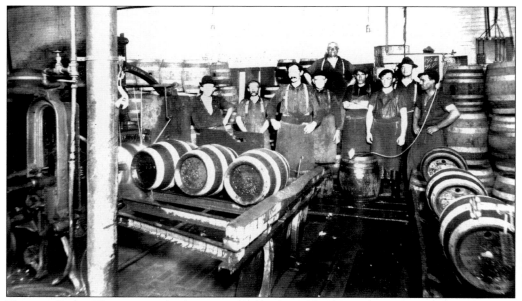

KEGS OF BEER. The men in the keg room inside the Old German Brewing Company pose for a quick photo before filling more kegs. The Old German Brewing Company had an annual capacity of 250,000 barrels of beer and ale. (From the Herman and Stacia Miller Collection, courtesy of the Mayor and City Council of Cumberland, Maryland.)

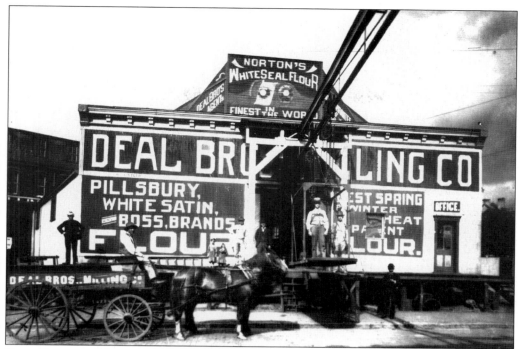

DEAL BROTHER MILLING COMPANY. Farmers could bring their own wheat grain to be milled in Cumberland or locals could purchase high quality flour from the Deal brothers. Later the mill expanded and became the Cumberland Flour Company, which was located off of Henderson Boulevard. (From the Herman and Stacia Miller Collection, courtesy of the Mayor and City Council of Cumberland, Maryland.)

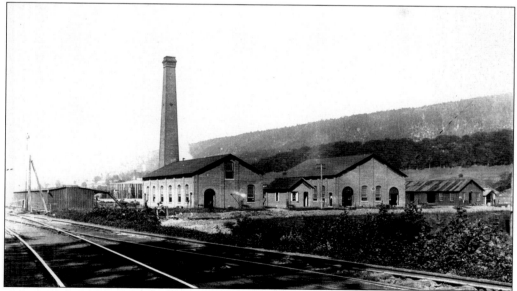

LOCUST GROVE PAPER MILL. This mill was located just northwest of Cumberland across Wills Creek in the Narrows. (From the Herman and Stacia Miller Collection, courtesy of the Mayor and City Council of Cumberland, Maryland.)

CUMBERLAND GLASS COMPANY. Located in LaVale, the Cumberland Glass Company opened in 1932, occupying an old distillery company warehouse. It produced drinking glasses of all sizes for the hotel and restaurant industry until 1961. (Courtesy of Nadeane Gordon.)

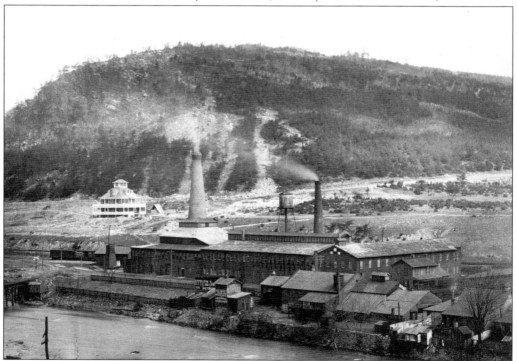

WELLINGTON GLASS COMPANY. Built in 1884, Wellington Glass Company was originally the National Glass Company and was purchased by Wellington in 1909. It was located on North Mechanic Street in the north end of Cumberland. Fire leveled the building in February 1920. (Courtesy of Nadeane Gordon.)

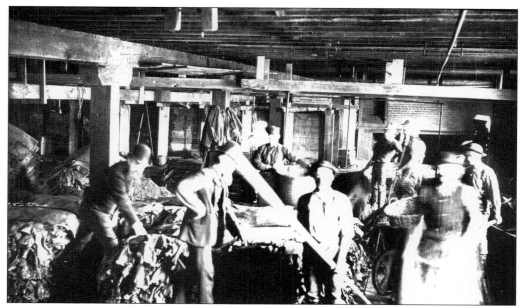

TANNERY. The tanning business thrived in the city of Cumberland. People from within Cumberland and neighboring communities purchased finished leather for saddles, bridles, shoes, belts, etc. (From the Herman and Stacia Miller Collection, courtesy of the Mayor and City Council of Cumberland, Maryland.)

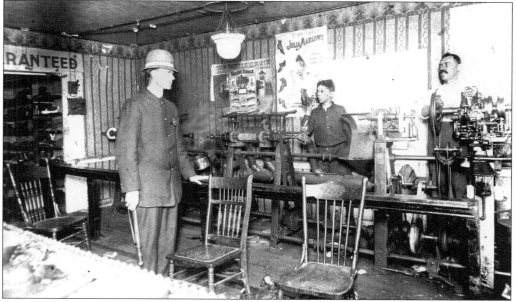

FRAM'S SHOE STORE, 1910. Shoe stores in the early 1900s had a totally different look than modern stores. A customer, like this police officer (William Cubbage), would go into a shoemakers store and order a pair of shoes to be made. Here this father (Harry Fram) and son (Ben Fram) are in the middle of filling an order at their store, which was located on North Mechanic Street, where the Rubber Union Hall was located. (From the Herman and Stacia Miller Collection, courtesy of the Mayor and City Council of Cumberland, Maryland.)

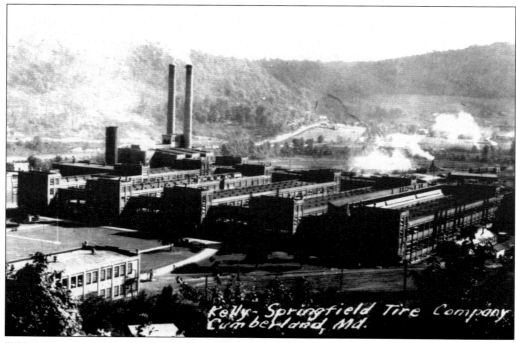

GO PLACES ON KELLYS!

VISIT KELLY'S BOOTH AT THE INDUSTRIAL EXHIBITION!

SEE THE SLIDE PICTURES OF THE KELLY FACTORY!

LEARN HOW *Armorubber* KELLYS ARE MADE!

Free Souvenirs Slide Pictures

THE KELLY SPRINGFIELD TIRE COMPANY
Cumberland, Maryland Retail Store 129 S. Mechanic St.

KELLY SPRINGFIELD TIRE COMPANY. In 1916, the contract was settled for the Kelly Springfield Tire Plant to be located in Cumberland. The company chose the city over 41 other locations. The tire plant, under construction in this photograph, was completed in 1920. The plant closed its doors in 1987. (From the Herman and Stacia Miller Collection, courtesy of the Mayor and City Council of Cumberland, Maryland.)

KELLY SPRINGFIELD TIRE COMPANY ADVERTISEMENT. The area's first retail store for Kelly Tires was on Mechanic Street in Cumberland. (Courtesy of Nadeane Gordon.)

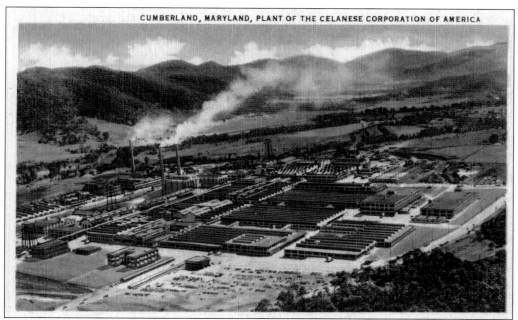

CELANESE CORPORATION OF AMERICA. The Celanese plant was built in 1920 on the outside of town. It was first owned by a sister company in Britain and known as the American Cellulose Chemical Manufacturing Corporation (Amcell); it changed its name shortly after opening for production. The plant produced synthetic fiber and yarns for clothing; it ceased production in 1983. The building was razed in 1994 for the construction of the Western Maryland Correctional Institution, which opened in 1996. (Courtesy of Nadeane Gordon.)

CELANESE CORPORATION OF AMERICA ADVERTISEMENT. The Celanese Company tried to make clients and the general public realize the uses of synthetic fibers and yarns in clothing and other items. They advertised that their fibers were cheaper than silk and just as nice. (Courtesy of Nadeane Gordon.)

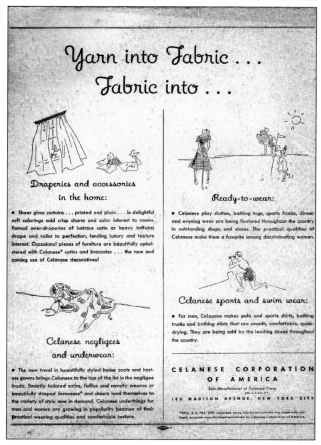

WESTERN MARYLAND HOSPITAL. The hospital was founded in the early 1890s by women; they cared to the men who were injured working on or around the railroad. (Courtesy of Nadeane Gordon.)

PACA STREET FIRE HOUSE. One of the first fire houses in the city was located on the west side of Cumberland. A small barn-style building housed the hose carts for the firefighters. At first, the fire department worked on a volunteer basis. (Courtesy of Nadeane Gordon.)

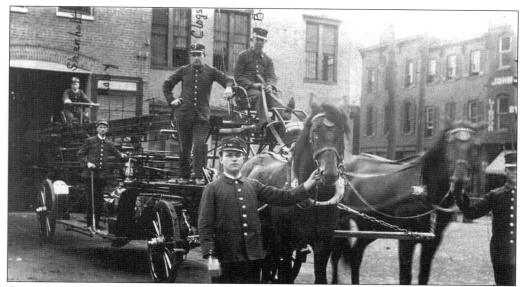

CUMBERLAND FIRE DEPARTMENT. The next home for the fire department was on North Mechanic Street; at this location they had a stable for their horses and a garage-style building for their horse-drawn fire hose wagon. In 1906, the Cumberland Fire Department became a paid municipal department for the City of Cumberland. There were two stations: Station #1 was located near City Hall with four men on duty and Station #2 was located on Browning Street with three men on duty. (Courtesy of Allegany County Historical Society.)

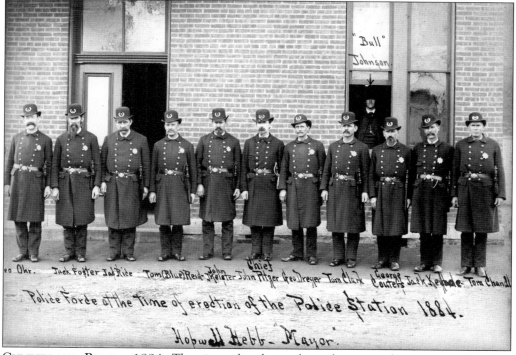

CUMBERLAND POLICE, 1884. The city police have always been proud to serve and protect Cumberland's citizens. (Courtesy of Allegany County Historical Society.)

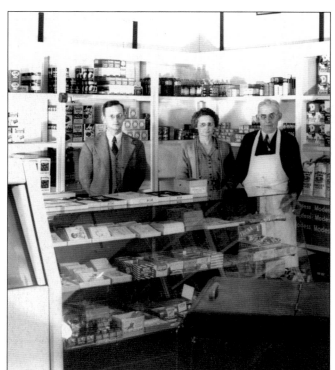

HUTTERS STORE—CORNER OF HOLLAND STREET AND COLUMBIA AVENUE. Taken during WWII, this photograph shows Alfred Hutter, Maude Hutter, and Luther Hutter Sr., the owners and operators of the store. This was one of Cumberland's many family-owned and operated stores. (Courtesy of Paul Hutter.)

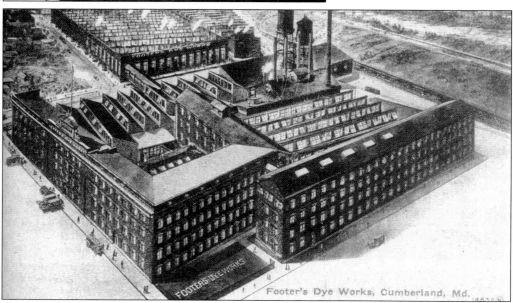

FOOTER'S DYE AND CLEANING WORKS. This company was started by Thomas Footer, an immigrant from England, in a one-room basement on South Centre Street. After many expansions, the plant was built in 1904 and employed over 500 people, including 200 women and girls. Curtains from the White House were even shipped here to be cleaned because of the care that the employees provided each order. Like many businesses, Footer's went out of business during the Great Depression in July 1937. (Courtesy of Nadeane Gordon.)

54

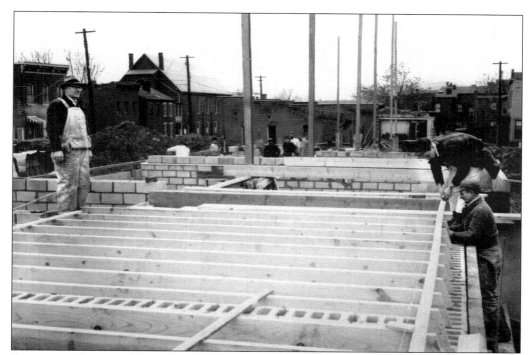

BUILDING HOUSING PROJECT. Benjamin Banneker, on Frederick Street, was one of the housing projects in Cumberland. As the population of workers with large families in need of low income housing grew, many local builders were employed to build such housing. (From the Herman and Stacia Miller Collection, courtesy of the Mayor and City Council of Cumberland, Maryland.)

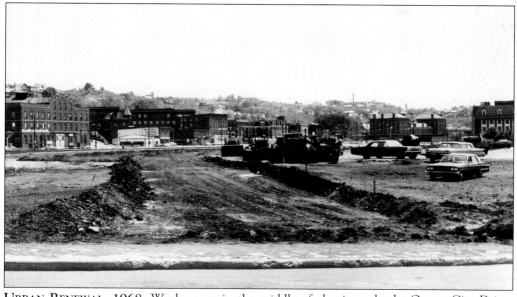

URBAN RENEWAL, 1968. Workers are in the middle of clearing a lot by Queen City Drive. Today this area is the site of a shopping center with McDonalds and Value City. (Courtesy of Nadeane Gordon.)

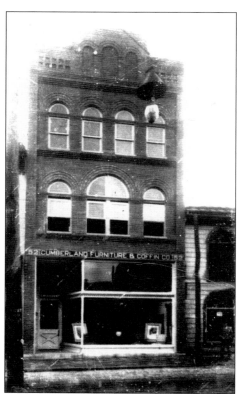

CUMBERLAND FURNITURE & COFFIN COMPANY, 1895. North Centre Street at Henry Street was another building company. This company had carpenters that constructed beautiful home furnishings. They were also the local favorites for coffin-making. It was common for furniture stores to also design and build coffins for townspeople. (From the Herman and Stacia Miller Collection, courtesy of the Mayor and City Council of Cumberland, Maryland.)

CRYSTAL LAUNDRY, 1912. Women could find employment at laundries and dry cleaning businesses like this one that was located on Mechanic Street. (Courtesy of Nadeane Gordon.)

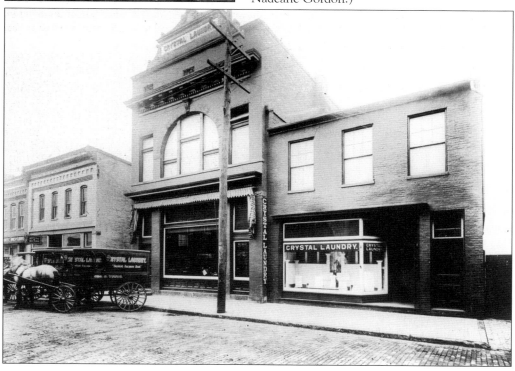

Five
WHEN WE PLAYED

When most people think of Cumberland, they think of the city as an industrial or railroad town. Not until recently did people start thinking of Cumberland as a place to play and have fun. Cumberland and the surrounding areas have many entertaining places where one can relax with friends and family.

The city was known for its theatres and the major productions that traveled through the area. To outsiders, the city hall was at one time known more for being a music hall than a municipal building. There were several theatres and music halls in the area; people could find just about anything they liked in a five-mile radius.

Parks were another well-known spot for relaxing and entertaining in Allegany County. A couple of local favorites during the 1800s were Riverside Park and the Narrows Park. During the Great Depression, the WPA constructed another favorite, Constitution Park, as a project in 1934.

Cumberland has always had a strong sports following. Whether the sport is baseball, football, basketball, or lawn games, there are crowds and rivalries. One of the largest ongoing rivalries has been the homecoming football game between Big Red (Fort Hill High) and Big Blue (Allegany High). Alumni still come home from all over the country to support their teams.

There have always been a large number of bars and clubs/dancehalls in the Cumberland area. At one time, it was rumored that there were two bars for every church in the city, which is not surprising since there were several breweries and distilleries in the area. At the time, bars and taverns were no place for a lady to be found, so they were a man's getaway from "his troubles."

Cumberland basically had a little taste of everything to keep the population happy and content with their close living quarters. It did not matter if you were rich or poor, the area had something to offer folks for their leisure time. Many times Cumberlanders would come up with their own ideas for entertainment, including parades and balls.

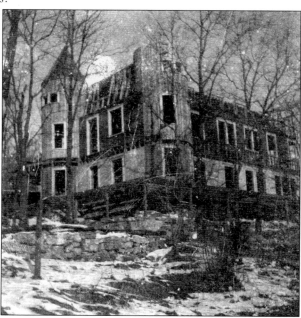

WILLS MOUNTAIN SANITARIUM. In 1899, this beautiful inn opened as the Wills Mountain Inn and an Elk's Club meeting house with over 40 rooms. The beautiful Victorian mansion was built on top of Wills Mountain near Lovers Leap. In 1902, it was sold and converted into a sanitarium. It burned down in 1930, during the Great Depression. (Courtesy of Nadeane Gordon.)

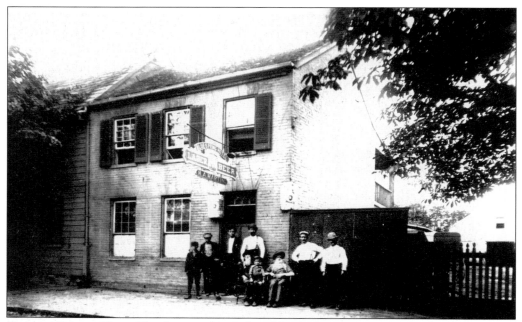

CENTRE STREET BAR. This bar was located on North Centre Street. Every bar had its own regulars from the neighborhood. Many of these bars were only closed for two hours (3 a.m. to 5 a.m.) because they catered to the swing shifts of the industrial plants that they were located nearby. Men could stop in at any time and get a drink or maybe breakfast, dinner, or supper. (From the Herman and Stacia Miller Collection, courtesy of the Mayor and City Council of Cumberland, Maryland.)

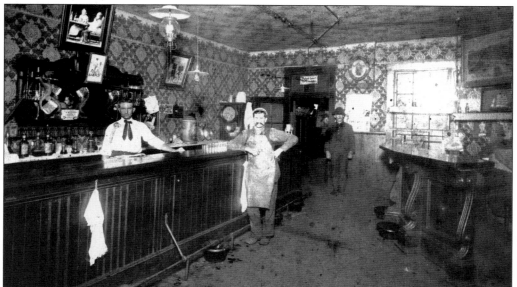

INSIDE A TYPICAL LOCAL BAR, 1900. It is no wonder that bars were not considered to be a place for ladies. What woman in her right mind would want to step foot into this place? It was definitely a man's domain. (From the Herman and Stacia Miller Collection, courtesy of the Mayor and City Council of Cumberland, Maryland.)

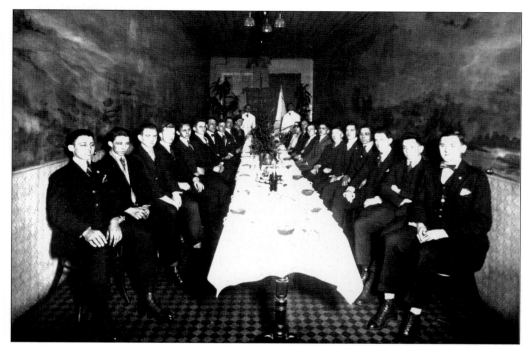

A MEN'S CLUB. There were many organizations and clubs in Cumberland that did not allow women. To name a few: the Redman Lodge, Scorpion Club, the Ali Ghan Shrine Club, the Masons, the Moose Lodge, the Elks Lodge, and the Lions Club. However, most of these clubs and lodges had corresponding women's groups for their wives to join. (From the Herman and Stacia Miller Collection, courtesy of the Mayor and City Council of Cumberland, Maryland.)

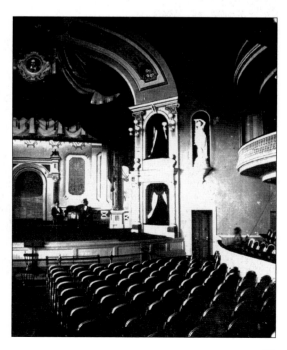

THE ACADEMY OF MUSIC HALL, 1876. This beautiful hall hosted many productions, plays, and musical recitals. This is a view of the stage and box seats. Cumberland lost this beauty to a fire in 1910. (From the Herman and Stacia Miller Collection, courtesy of the Mayor and City Council of Cumberland, Maryland.)

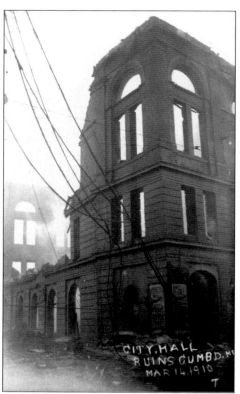

REMAINS OF THE ACADEMY OF MUSIC CITY HALL. Although the fire department fought the fire for hours, it swept through the building and destroyed everything in its path. (From the Herman and Stacia Miller Collection, courtesy of the Mayor and City Council of Cumberland, Maryland.)

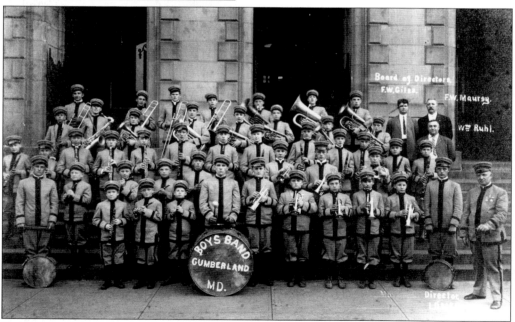

CUMBERLAND BOYS BAND. Music was a favorite pastime for the citizens of Cumberland. They taught their children at a young age how to play an instrument. (Courtesy of Allegany County Historical Society.)

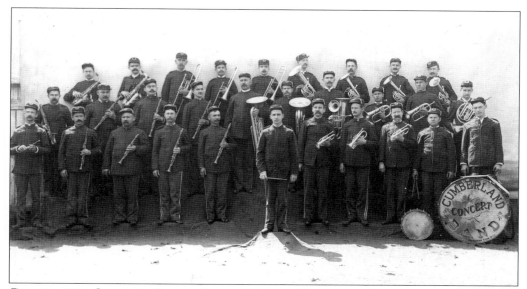

CUMBERLAND CONCERT BAND. Many adults would continue to entertain a passion for music and join local marching and concert bands. It was not easy to get into one of these bands; there were try-outs of many kinds to become a member. (Courtesy of Allegany County Historical Society.)

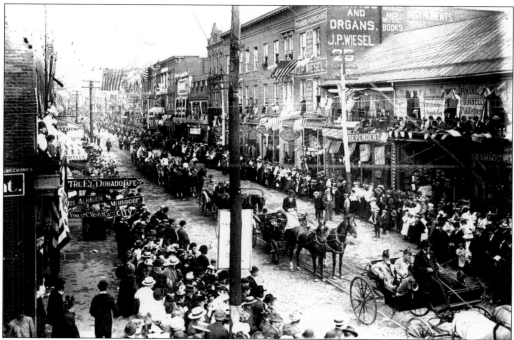

LABOR DAY PARADE, LATE 1880s. People would come from miles around to watch Cumberland's parades. Everyone wanted to see the "who's who" of society and experience the excitement of the day. Baltimore Street is packed from the street to the rooftops. (From the Herman and Stacia Miller Collection, courtesy of the Mayor and City Council of Cumberland, Maryland.)

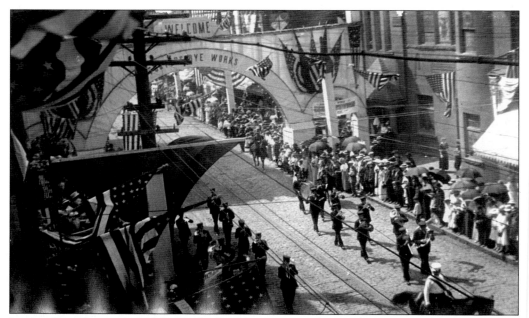

LABOR DAY PARADE, 1919. Cumberland has always taken pride in national holidays; there was a parade for almost every one. At this Labor Day parade, the city's patriotism shines brightly. (Courtesy of Allegany County Historical Society.)

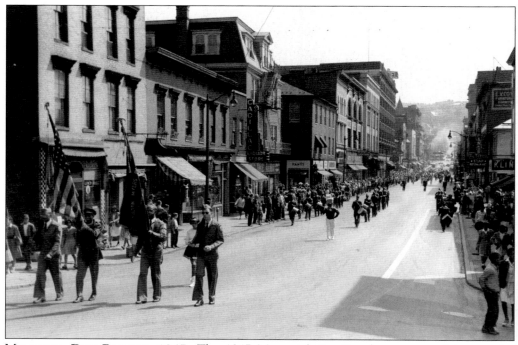

MEMORIAL DAY PARADE, 1947. The 1947 Memorial Day Parade was a special event for Cumberlanderd because the citizens had a chance to honors those who fought and were killed in World War II.(Courtesy of Allegany County Historical Society.)

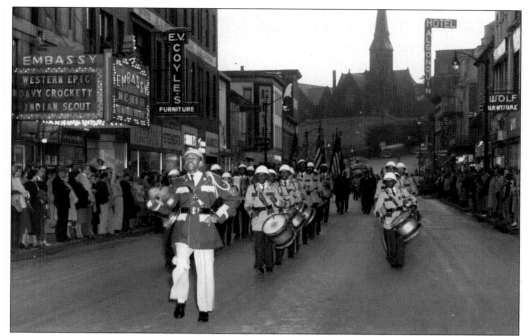

LABOR DAY PARADE. It is amazing to see how much Baltimore Street changed from the 1800s to this picture from the 1950s. Pride can still be seen on the faces of the people participating in the parade. (Courtesy of Nadeane Gordon.)

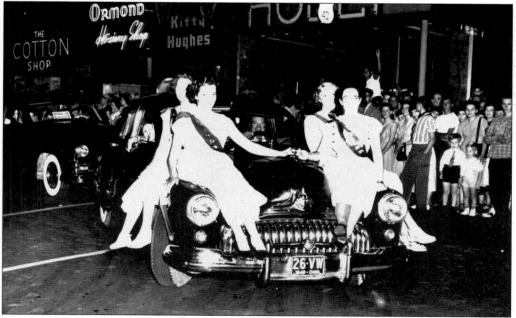

BEAUTY QUEENS, 1944. A parade would not be complete without a couple of beauty queens waving at spectators. These beauties better hang on tight while riding on the hood of that old Buick. (From the Herman and Stacia Miller Collection, courtesy of the Mayor and City Council of Cumberland, Maryland.)

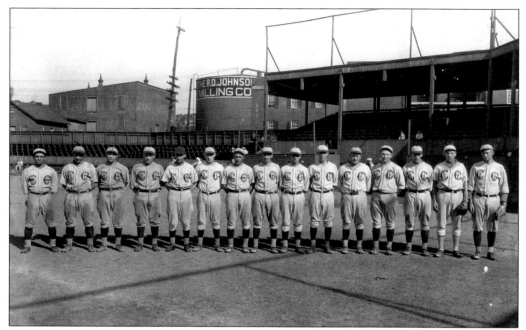

CUMBERLAND COLTS BASEBALL TEAM. The city had much pride in America's favorite past time—baseball. There were several different teams and leagues for all ages. (Courtesy of Allegany County Historical Society.)

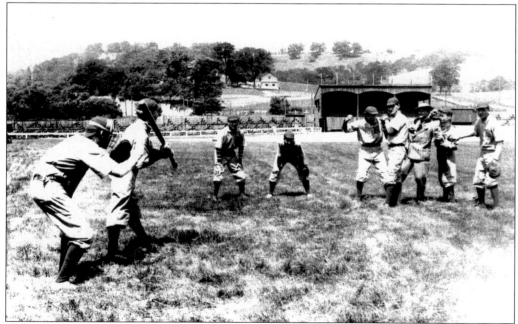

BOYS AT PLAY, 1905. Baseball fields were built all around Cumberland to accommodate the baseball fever. Local clubs and organizations sponsored teams for summer leagues and alumni dug deep in their pockets to keep the high school games alive. (From the Herman and Stacia Miller Collection, courtesy of the Mayor and City Council of Cumberland, Maryland.)

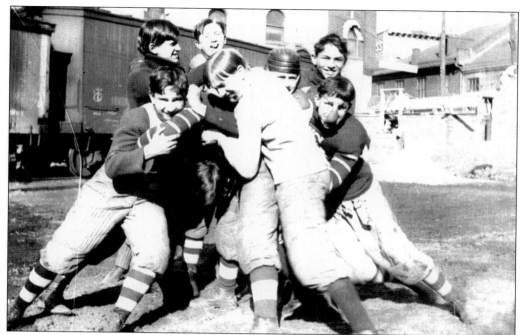

IT'S IN THE BLOOD. Football has been Cumberland's game for years. Many fathers would give their sons footballs as soon as they were big enough to hold one. These boys probably spent hours tossing the pigskin around before joining this league, the Cumberland Colts. (From the Herman and Stacia Miller Collection, courtesy of the Mayor and City Council of Cumberland, Maryland.)

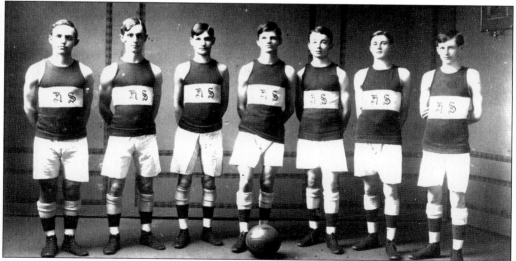

ALLEGANY SCHOOL BASKETBALL TEAM, 1905–1906. Another local favorite is the game of basketball. It kept kids active through the winter months and broke the feeling of cabin fever. Nothing compares to walking into a packed gymnasium on a cold winter evening and feeling the heat of the crowd and the excitement of the players. The team members pictured are Robinson, Tice, Wolford, Stein, Marean, Schaffer, and Derr. (From the Herman and Stacia Miller Collection, courtesy of the Mayor and City Council of Cumberland, Maryland.)

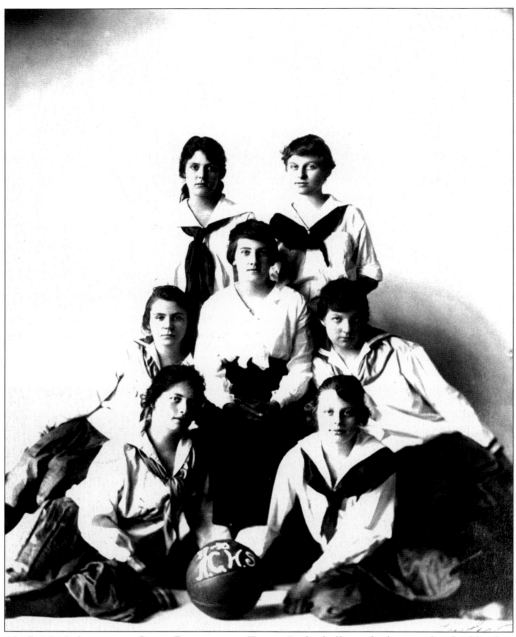

1917–1918 Allegany Girls Basketball Team. Basketball was for boys and girls alike, but it appears the boys had an easier time playing it—imagine playing in long-sleeved shirts, wool skirts, and hose. The girls really had a workout during their games. (From the Herman and Stacia Miller Collection, courtesy of the Mayor and City Council of Cumberland, Maryland.)

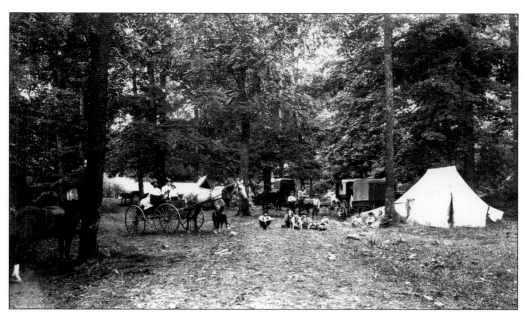

CAMP GROUNDS, 1898. This camp site was located in LaVale. People loved to get out of the city and camp, just as we do today. (From the Herman and Stacia Miller Collection, courtesy of the Mayor and City Council of Cumberland, Maryland.)

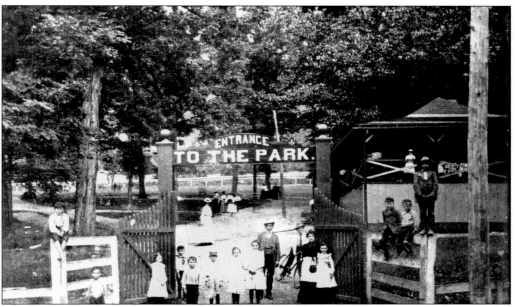

NARROWS PARK. This park was also located in LaVale at the mouth of the Narrows. It was developed in the mid-1800s as a place for people to could get out of town and enjoy the countryside. The park grew so popular that when the Cumberland Electric Railway started, one of its destinations was Narrows Park. (From the Herman and Stacia Miller Collection, courtesy of the Mayor and City Council of Cumberland, Maryland.)

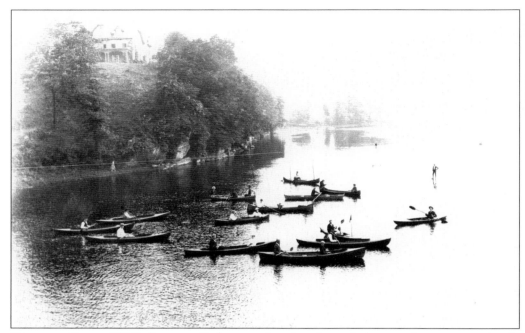

POTOMAC PARK, 1895. Potomac Park was a favorite of people because it was conveniently located on the Potomac River within city limits. The park was an easy walk from any location in Cumberland. People would gather for picnicking, swimming, and canoeing. There were also paddle steamboat rides down the river available on the Potomac Queen. (From the Herman and Stacia Miller Collection, courtesy of the Mayor and City Council of Cumberland, Maryland.)

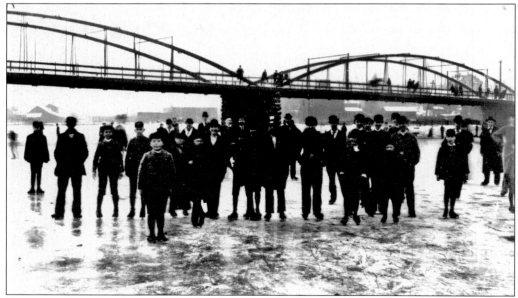

ON ICE, 1895. Riverside Park was not only a favorite gathering place during the warm summer months, but also during the cold. Adults and children gathered at the park to ice skate on the Potomac River in the dead of winter. (From the Herman and Stacia Miller Collection, courtesy of the Mayor and City Council of Cumberland, Maryland.)

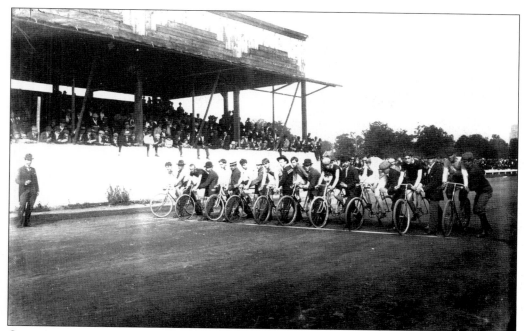

OLD FAIRGROUNDS IN SOUTH CUMBERLAND. The original fairgrounds were located in South Cumberland. The grounds were used for the annual fair and other competitions until the 1920s, when the new fairgrounds were developed. (From the Herman and Stacia Miller Collection, courtesy of the Mayor and City Council of Cumberland, Maryland.)

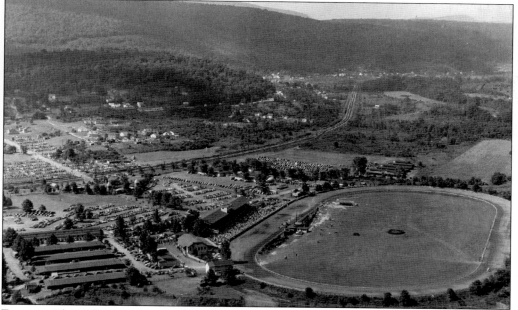

FAIRGO. The Allegany County fairgrounds were known as Fairgo. It was not only built to accommodate the annual agricultural exposition and carnival rides, but also horse races. The half-mile track hosted a two-week meet. The horse track closed in 1961. (Courtesy of Nadeane Gordon.)

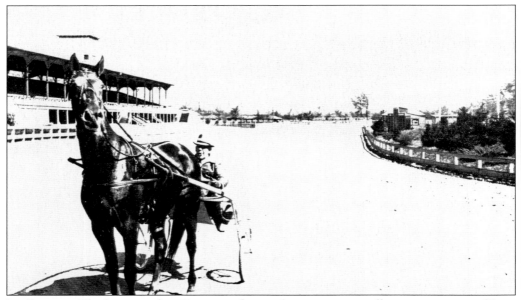

JIG RACING. The horse track at Fairgo was host to horseracing as well as jig-cart racing. (From the Herman and Stacia Miller Collection, courtesy of the Mayor and City Council of Cumberland, Maryland.)

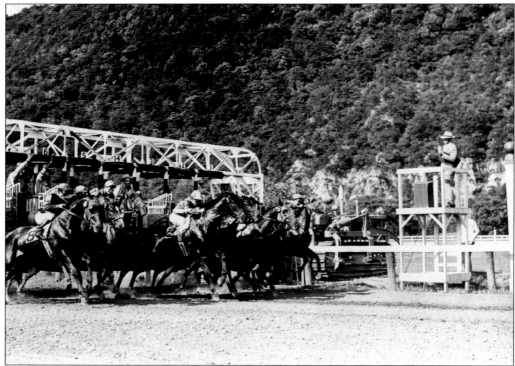

OUT OF THE GATES. The horse track was a beautiful track that fancied horse lovers and spectators alike. Bets were $2 and the stands were almost always full until the late 1950s, when the larger track became popular. (Courtesy of Allegany County Historical Society.)

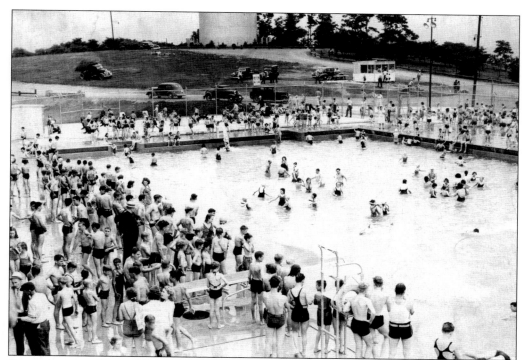

CONSTITUTION PARK. When the WPA constructed Constitution Park in the 1930s, it was a hit with the citizens of Cumberland. The park furnished pavilions for gatherings and picnics. There was an amphitheater for entertainment of all kinds, a playground for children, and a pool. (From the Herman and Stacia Miller Collection, courtesy of the Mayor and City Council of Cumberland, Maryland.)

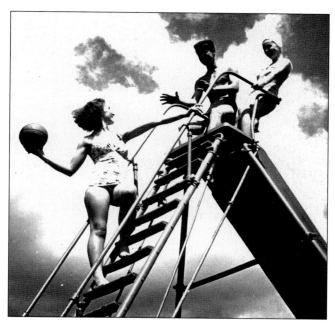

EVERYONE'S FAVORITE. Constitution Park became best known for its large public pool. Not only did it have a pool, but also this huge slide, which was everyone's favorite. (From the Herman and Stacia Miller Collection, courtesy of the Mayor and City Council of Cumberland, Maryland.)

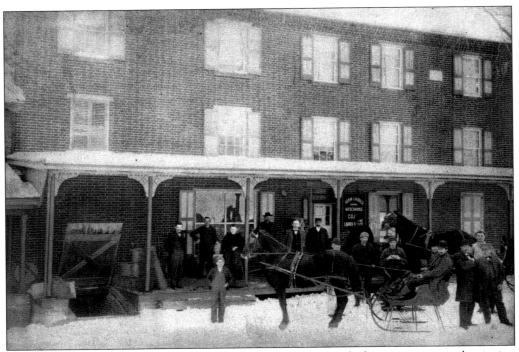

FUN IN THE WHITE STUFF. Winter weather did not keep people from going out and enjoying themselves. Cumberlanders have always tried to make the best of things even during the long, cold winters. (From the Herman and Stacia Miller Collection, courtesy of the Mayor and City Council of Cumberland, Maryland.)

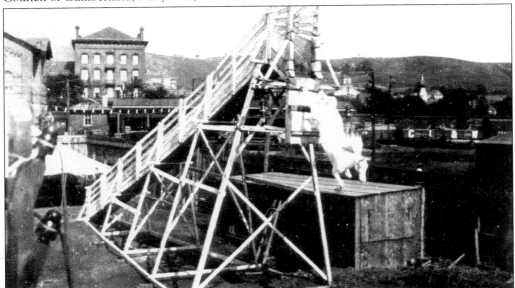

THE CIRCUS IS IN TOWN. Cumberland has been a stop for all types of circuses through the years. This is a photograph of one of the memorable tricks they had to offer as entertainment—a trained diving horse. (From the Herman and Stacia Miller Collection, courtesy of the Mayor and City Council of Cumberland, Maryland.)

Six
WHERE WE SHOPPED

Cumberland has always been a place to shop. In the beginning, as a trade post on the frontier, people came to "shop" and trade for goods at least twice a year. As the city grew, businesses and stores began to develop in and around town. Soon Cumberland became a service city to the surrounding area by offering dry goods, linens, hardware, groceries, and other products.

Once the canal and the railroad systems made their way into the city, people found it much easier to find goods in stores. Exotic items could be easily shipped in by rail or canal and this impressed customers. Cumberland was seen as a metropolitan town ranking with Baltimore, Pittsburgh, and Philadelphia.

Many local craftsmen would either open their own shops or sell their products to shop keepers. They produced goods for consumers and knew that the best type of advertising was word of mouth. The craftsmen took pride in their products and shops. The merchants understood that if their customers trusted them, they would return and maybe bring a friend. All businesses worked this way whether it was a butcher store, a shoe store, a general store, or even a jewelry store.

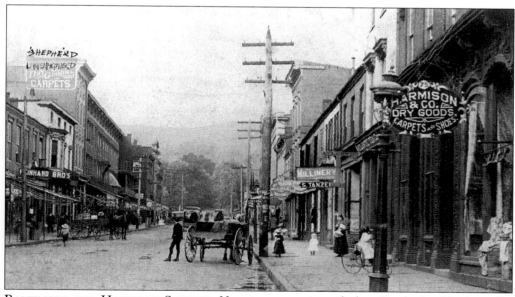

BALTIMORE AND HARRISON STREETS. Here is a great view of what Cumberland had to offer shoppers. In a one-block view there is a dry goods store, bar, a hotel, and a gentleman's store. (Courtesy of Allegany County Historical Society.)

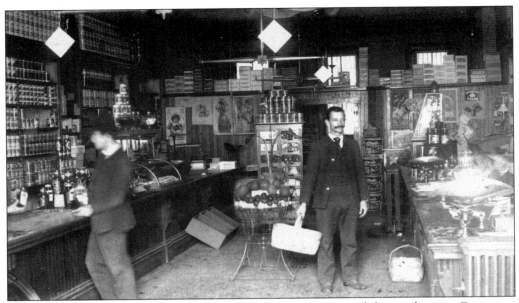

DRY GOODS STORE. This photograph offers a look inside a typical dry goods store. Customers bought canned goods, candy, flour, sugar, and pantry items. (From the Herman and Stacia Miller Collection, courtesy of the Mayor and City Council of Cumberland, Maryland.)

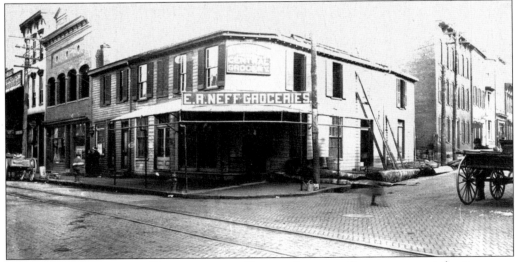

E.R. NEFF GROCERIES ON BALTIMORE AND CENTRE STREETS. Grocery stores at the time were usually strictly for perishable items like fresh fruit, vegetables, eggs, butter, etc. Only in-season items that were locally grown were sold, unless the railroad could ship items here before they would spoil. (From the Herman and Stacia Miller Collection, courtesy of the Mayor and City Council of Cumberland, Maryland.)

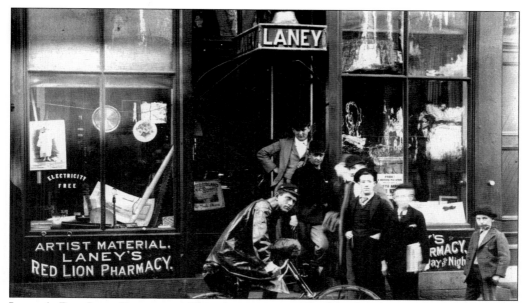

LANEY'S RED LION PHARMACY. This pharmacy was a local landmark in itself. Mr. Laney had the foresight to mass-produce numerous postcards of Cumberland with his pharmacy name on the front. Laney's Red Lion Pharmacy boasted the largest stock of medicines in the city. (From the Herman and Stacia Miller Collection, courtesy of the Mayor and City Council of Cumberland, Maryland.)

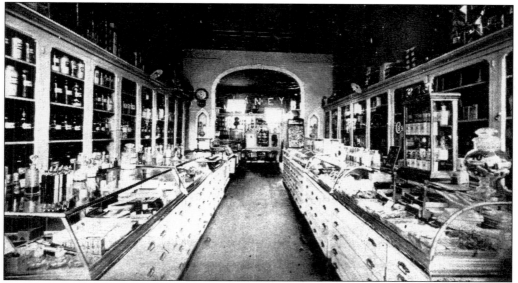

INSIDE LANEY'S. The pharmacy was established in 1877 and served its customers well. Their famous postcards were a great advertising scheme for the business. Today some of the postcards are the only remaining photographs of buildings and landmarks in Cumberland. To receive a postcard, customers collected tickets with each purchase; once a customer had a dollar's worth of tickets, he or she would receive a free photograph of the beautiful scenery of Cumberland. (From the Herman and Stacia Miller Collection, courtesy of the Mayor and City Council of Cumberland, Maryland.)

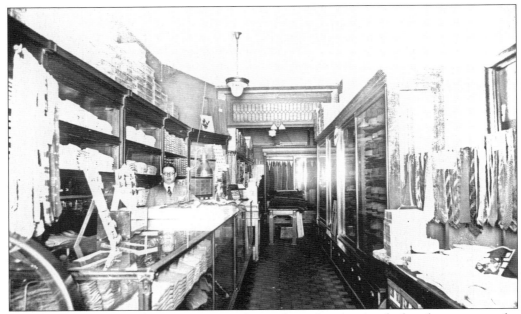

GENTLEMAN'S STORE. This interior view of a gentleman's store reveals that there was not the glitz and glamour of stores today. Stores offered practical products; when people shopped, they went only for things they needed. (From the Herman and Stacia Miller Collection, courtesy of the Mayor and City Council of Cumberland, Maryland.)

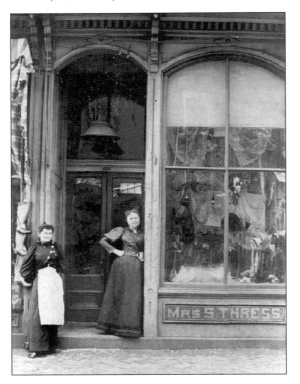

MRS. S. THRESS LADIES STORE. Ladies stores were much like the gentleman's store—very practical. There may have been more decorations to appeal to ladies tastes, but nothing like today's standards. (Courtesy of Allegany County Historical Society.)

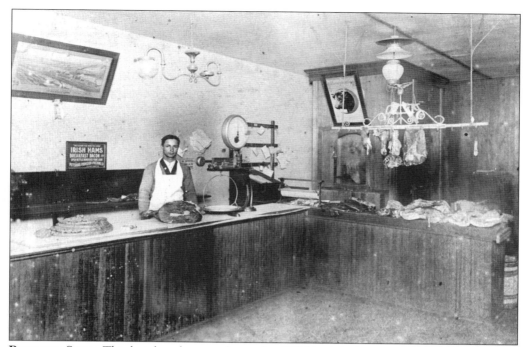

BUTCHER SHOP. This butcher shop was located at 510 Virginia Avenue. The shop was opened and operated by Otis Wisman. Shops like Otis's would purchase livestock from local farmers, butcher the meat, and sell it to the public. (Courtesy of Allegany County Historical Society.)

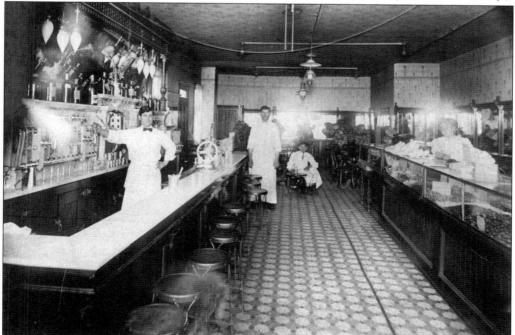

CANDY KITCHEN. Located at 506 Virginia Avenue, Candy Kitchen specialized in handmade candies and had a soda fountain. (Courtesy of Allegany College of Maryland Library.

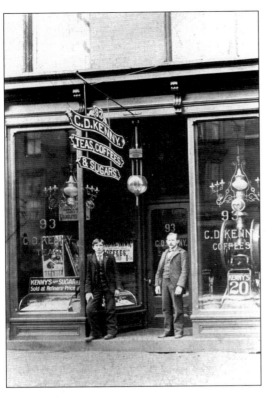

COFFEE, TEA, AND SUGAR. D.C. Kenney's Store was located on Centre Street. This photo was taken in 1909. Many people think that specialty coffee and teas shops are a new invention for today's market, but special blend and imports were just as popular during the Gilded Age, especially among the upper-middle class who hosted high teas and socials. (Courtesy of Allegany County Historical Society.)

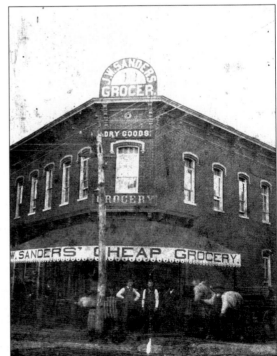

J.W. SANDERS CHEAP GROCERY, 1895. Everyone is looking for a bargain and the Sanders family took advantage of this idea when naming their store. (Courtesy of Allegany County Historical Society.)

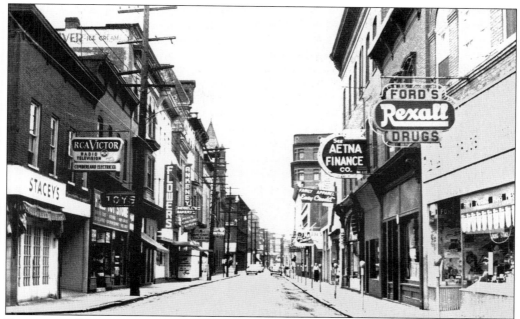

BALTIMORE STREET, 1962. As the decades passed and automobiles increased in use, the appearance of downtown changed. Streets had to be widened to allow for two lanes of traffic and street side parking. (From the Herman and Stacia Miller Collection, courtesy of the Mayor and City Council of Cumberland, Maryland.)

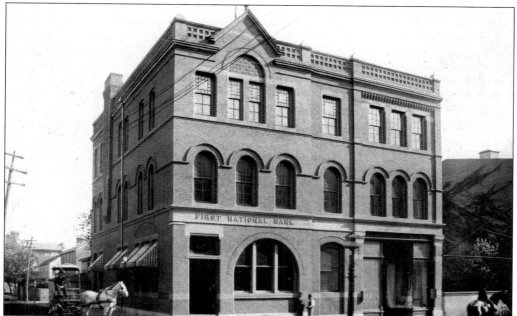

FIRST NATIONAL BANK. This bank was built at the turn of the 20th century on the corner of Baltimore and South George Streets. The First National Bank is a perfect example of the architectural style of bank buildings at the time; they were multi-floor, massive buildings for the time. (Courtesy of Allegany County Historical Society.)

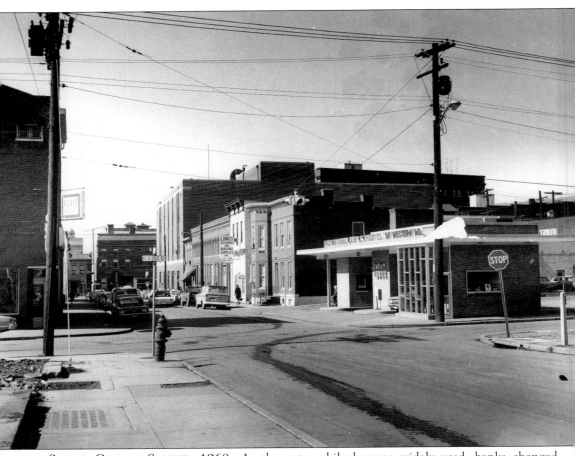

SOUTH GEORGE STREET, 1968. As the automobile became widely used, banks changed their services. Instead of having to get out of your car to bank, people could use the drive-thru bank service, like this one pictured on the corner of George and Union Streets. (From the Herman and Stacia Miller Collection, courtesy of the Mayor and City Council of Cumberland, Maryland.)

Seven
MIND, BODY, AND SPIRIT

Cumberland has been a place in Maryland where people have found themselves emotionally, physically, and spiritually for hundreds of years. The natural cut through Wills and Haystack Mountains was an inviting place to explore, relax, and settle even before Europeans set foot in the western regions of the Mid-Atlantic. Native Americans thought the river and the mountains were important spiritually; the land nourished their bodies and strengthened their minds.

When Europeans made their way to the region where Wills Creek pours into the Potomac, they too found the area as a great place to stop, regroup, and strengthen themselves. The Europeans—mostly English and German at first—settled in the valley and started Catholic, Lutheran, Methodist, Episcopal, and Presbyterian churches in the area. Other churches, such as the Baptist church, also moved into the area. Finally, the Jewish community started the B'er Chayim Temple.

The new settlers also started wonderful public and private schools to educate their children. There are also excellent instituions of higher education in Cumberland as well.

The city has also provided healthcare for decades to individuals in need of medical care. The first hospital in the area was actually started by a group of women who raised money to open the facility; this was to become known as Memorial Hospital. Sacred Heart Hospital was started by the Daughters of Charity, located on Decatur Street. Before these hospitals existed, Cumberland had make-shift hospitals during the French and Indian War and the Civil War.

Today, Cumberland is made up of beautiful church steeples. There are over 40 churches in the city and many of them are now lit at night for a glorious nightscape.

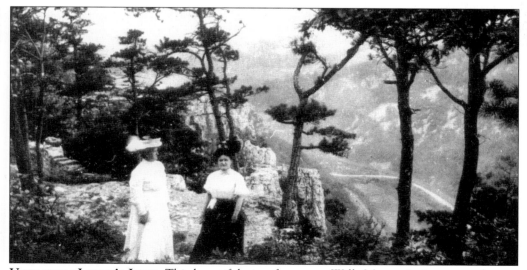

VIEW FROM LOVER'S LEAP. This beautiful view from atop Wills Mountain is a great place to get away and think about nature and life. Today, it overlooks the city of Cumberland. At one time, Shawnee Indians had summer encampments near this site. This overlook can make you feel closer to your maker and in tune with your body so you can focus on your thoughts. (From the Herman and Stacia Miller Collection, courtesy of the Mayor and City Council of Cumberland, Maryland.)

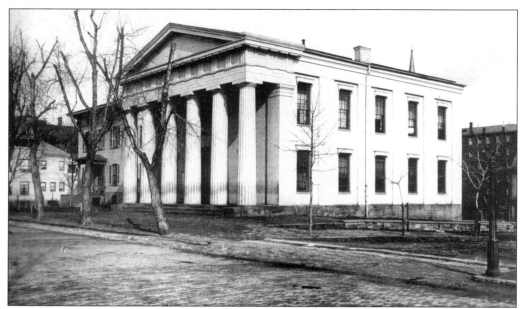

ALLEGANY COUNTY ACADEMY. This academy was started in 1849 for boys of the wealthy, later, it allowed girls to attend. During the Civil War, Allegany County Academy was used as a make-shift hospital. Today it is the main branch of the Allegany County Library System since 1934. (Courtesy of Nadeane Gordon.)

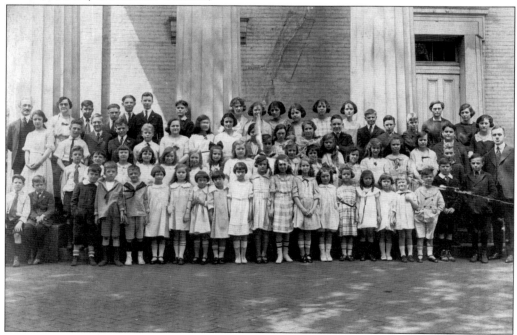

STUDENTS IN FRONT OF ALLEGANY COUNTY ACADEMY. This photo was taken on the Academy's 120th anniversary, May 27, 1921. Frank Henry Kaplon and eighth grade students are pictured. (From the Herman and Stacia Miller Collection, courtesy of the Mayor and City Council of Cumberland, Maryland.)

CENTRE STREET SCHOOL. Every neighborhood had its own school. This is a group of students from Centre Street School, located on North Centre Street. Today the school is a residence. (From the Herman and Stacia Miller Collection, courtesy of the Mayor and City Council of Cumberland, Maryland.)

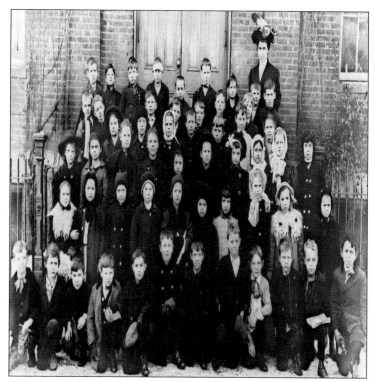

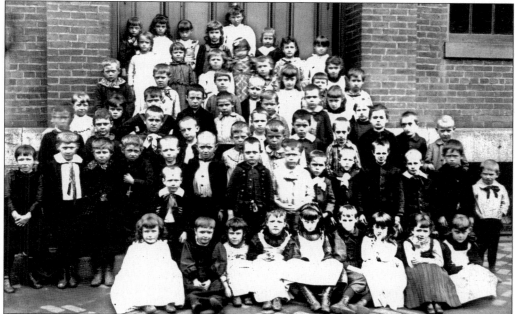

UNION STREET SCHOOL, 1890. The schools that were in neighborhoods were generally elementary schools. Once most students reached the age of twelve or fourteen, they entered the work force. (From the Herman and Stacia Miller Collection, courtesy of the Mayor and City Council of Cumberland, Maryland.)

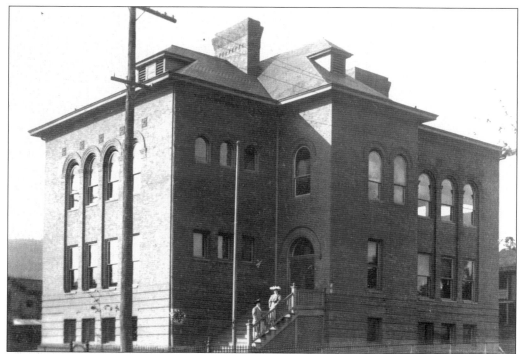

CUMBERLAND STREET SCHOOL. Many of these old school buildings still stand today in their original neighborhoods; many have been converted into private businesses or apartments. (Courtesy of Nadeane Gordon.)

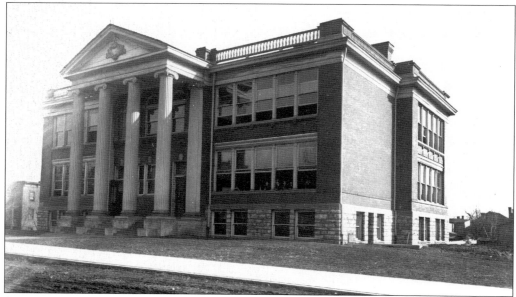

ALLEGANY HIGH SCHOOL. In 1908, Allegany High School replaced the Cumberland Street School and became the county's first public high school. The school's current location was built in 1926. Go Big Blue! (From the Herman and Stacia Miller Collection, courtesy of the Mayor and City Council of Cumberland, Maryland.)

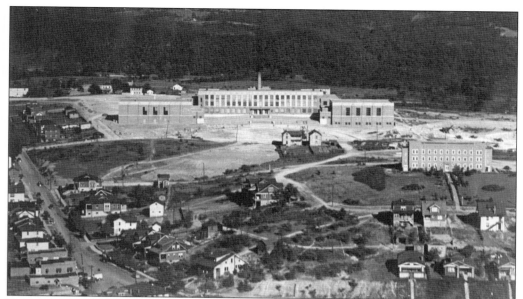

FORT HILL HIGH SCHOOL. When Fort Hill High School opened in 1936, a major school rivalry began between Allegany High School and Fort Hill School. Every Homecoming football game was a fight to become the best team in the city. Go Big Red! (Courtesy of NaDeane Gordon.)

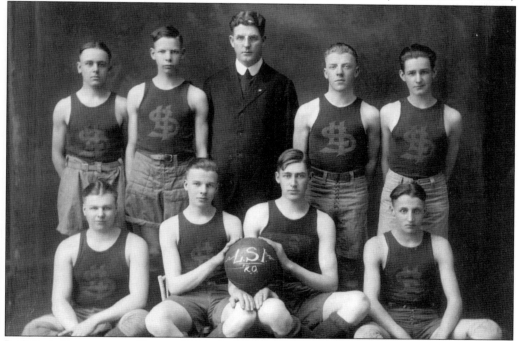

LaSALLE BASKETBALL TEAM, 1920. LaSalle was a Catholic boys' high school that later consolidated into Bishop Walsh High School. The school took the name Bishop Walsh from Bishop James Walsh, who grew up on Washington Street. He was imprisoned for ten years in the early 1960s as a political prisoner in China. (From the Herman and Stacia Miller Collection, courtesy of the Mayor and City Council of Cumberland, Maryland.)

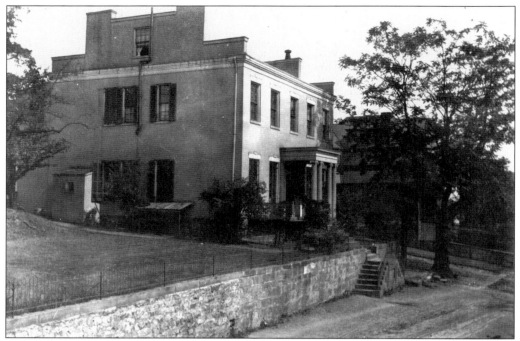

CUMBERLAND'S FIRST HOSPITAL. Located on Altamont Terrace and Union Street, the hospital was started to care for men who were injured on the railroad. (From the Herman and Stacia Miller Collection, courtesy of the Mayor and City Council of Cumberland, Maryland.)

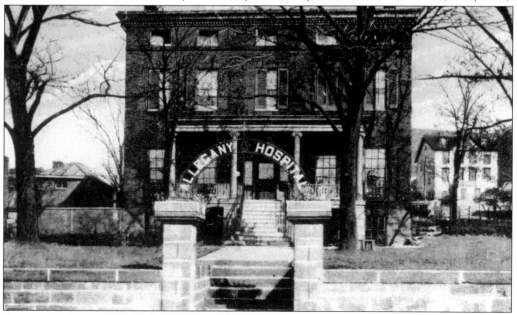

ALLEGANY HOSPITAL. Built in 1905, Allegany Hospital was another early hospital that was built in Cumberland. In 1911, the Daughters of Charity took over the management of Allegany Hospital. Sacred Heart Hospital on Seton Drive replaced the old hospital in 1967. (Courtesy of Allegany College of Maryland Library.)

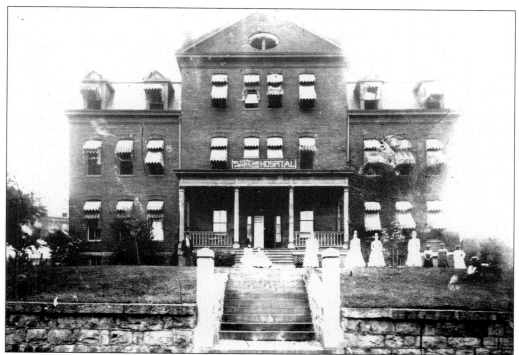

WESTERN MARYLAND HOSPITAL, 1890. Located on Baltimore Avenue, Western Maryland Hospital was closed after Memorial Hospital was built on Memorial Avenue on the east side of Cumberland. This building burned down in 1967. (From the Herman and Stacia Miller Collection, courtesy of the Mayor and City Council of Cumberland, Maryland.)

MEMORIAL HOSPITAL. This hospital was built in 1927–1928, on the east side of Cumberland and was also used as a teaching hospital for nurses. Dorms for the nurses were located on the grounds of the hospital, allowing easy access for the students. Today, it is part of the Western Maryland Healthcare System, along with Sacred Heart Hospital. (Courtesy of Allegany College of Maryland Library.)

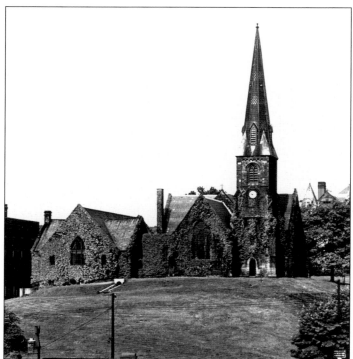

EMANUEL EPISCOPAL CHURCH. This church was started in 1809 as a small one-room church at the base of Fort Cumberland. As the population increased, the parish decided to build a new church. In 1849–1850, the church was built over the ruins of the fort and still stands on the site today. (From the Herman and Stacia Miller Collection, courtesy of the Mayor and City Council of Cumberland, Maryland.)

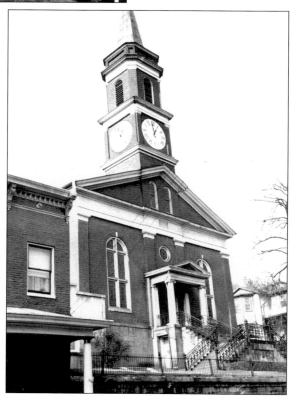

BELL CLOCK TOWER CHURCH, 1848. This church, originally the German Lutheran Church, and the German Catholic Church were under construction at the same time. While the churches were being built, the city fathers purchased a bell for a tower and told the churches that the first church to complete their steeple would be rewarded with the clock. The Catholic Church lost because the women of the Lutheran parish climbed the scaffolding at night and held lamps, allowing the men to build night and day. (From the Herman and Stacia Miller Collection, courtesy of the Mayor and City Council of Cumberland, Maryland.)

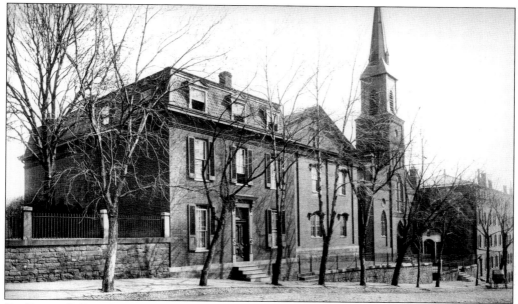

ST. PETER & PAUL'S CATHOLIC CHURCH. Originally the German Catholic Church, St. Peter & Paul's Catholic Church competed against the German Lutheran Church for the clock. When they completed the steeple, they left a space where the clock should have been placed; the church still has not placed a clock in the steeple. At one time, there was a monastery located beside the church where Capuchin Monks lived. A private Catholic elementary school, St. John Newman's, was also built near the church. The school was named for St. John Newman who selected the church site in 1848; construction of the church was completed in 1849. (Courtesy of Allegany County Historical Society.)

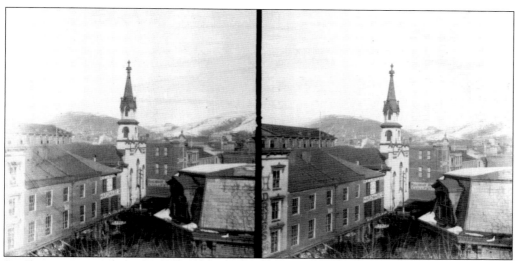

ST. PAUL'S LUTHERAN CHURCH, 1895. The Lutherans are the oldest Protestant congregation in the county. St. Paul's was originally located on the corner of Baltimore and Centre Streets. It was torn down and a new location was found on Washington and Smallwood Streets. (From the Herman and Stacia Miller Collection, courtesy of the Mayor and City Council of Cumberland, Maryland.)

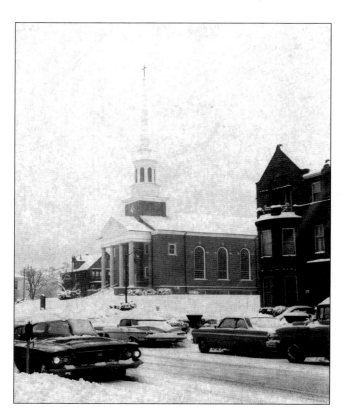

St. Paul's Lutheran Church. This is the second and present location of St. Paul's Church, built in 1957. (From the Herman and Stacia Miller Collection, courtesy of the Mayor and City Council of Cumberland, Maryland.)

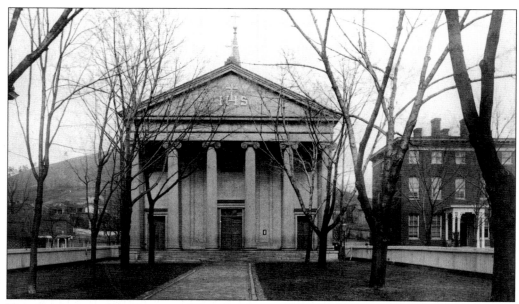

The Church of St. Patrick. This church was first named St. Mary's Church, but as the Irish-Catholic population grew in the area, the name was changed to St. Patrick's. The church was constructed between 1849 and 1851. (Courtesy of Nadeane Gordon.)

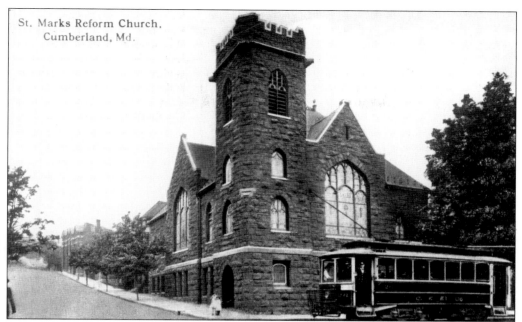

St. Marks Reform Church,
Cumberland, Md.

ST. MARK'S REFORM CHURCH. This beautiful Gothic Revival church is still located on Harrison Street. Today, it is known as St. Mark's Community Church. The original chapel was built in 1897; it was razed in 1912 for the present day church, which was completed in 1913. (Courtesy of Allegany College of Maryland.)

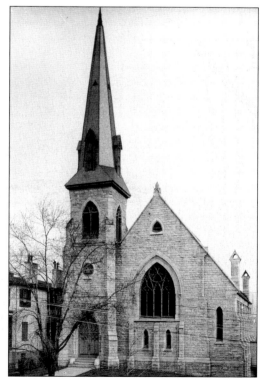

FIRST PRESBYTERIAN CHURCH. This church was built in 1871. When the church was first built, it did not have a spire; the spire was added in 1892. (Courtesy of Allegany College of Maryland.)

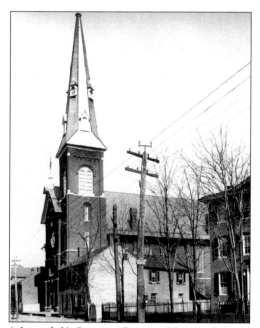 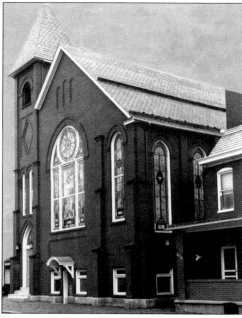

(*above, left*) **CENTRE STREET UNITED METHODIST CHURCH.** One of the oldest churches in the city, Centre Street United Methodist Church was constructed in 1871. Today, Humpty-Dumpty Pre-school Learning Center is located on the grounds of the church. (Courtesy of Allegany College of Maryland Library.)

(*above, right*) **ZION CHURCH.** In 1871, the first Zion Church was built in the north end of town on Mechanic Street. The current church was built in 1911, about the same time city hall was being built. (From the Herman and Stacia Miller Collection, courtesy of the Mayor and City Council of Cumberland, Maryland.)

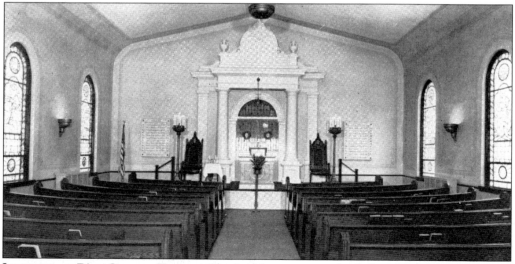

INTERIOR OF B'ER CHAYIM TEMPLE. The Jewish community built the temple in 1867 on the corner of Union and Centre Streets. Prior to the construction of the temple, the families met and worshiped in their homes. The congregation contributed weekly dues of 25¢ to pay for the construction. The temple also houses a religious school. (Courtesy of Lee Schwartz.)

Eight
FIRES AND FLOODS

Cumberland has not had good luck when it comes to fires and floods. Throughout its history, there have been reports of devastating fires and floods destroying homes, businesses, and property.

Almost every spring, Cumberland flooded. It is easy to see why the city was so prone to floods because at the north end of Cumberland, in the Narrows, Braddock Run flows into Wills Creek, Wills Creek then flows through town into the Potomac River. During the springs these streams would become full and crest their banks.

The floods were an annual spring cleaning for the city. They were only welcomed when there were no more than a few inches running through the streets; the one that changed Cumberland's opinion was the St. Patrick's Day Flood of 1936. After it swept through the city and left millions of dollars in damages, a plan was developed for flood control to protect the streets of Cumberland.

As for the fires, they were never welcomed. It seems fires in Cumberland were as regular as floods, but no one ever knew when they were going to happen. Many fires happened in the infancy of Cumberland's history because of the wide use of candles and oil lamps for lighting. Wood burning stoves were also a major cause of fires.

Cumberland factories were another major contributor to fires. There were not many, if any, safety regulations on equipment, and malfunctions caused fires. Many times, the machines would overheat, belts would slip, or the machines were not cleaned and maintained properly, which would cause fires. A fire often caused destruction of the building where it began and, many times, would spread through the street blocks.

These fires and floods have shaped much of the look of Cumberland today. Buildings, new and old, sit along the city streets. What does not destroy this city only makes it stronger.

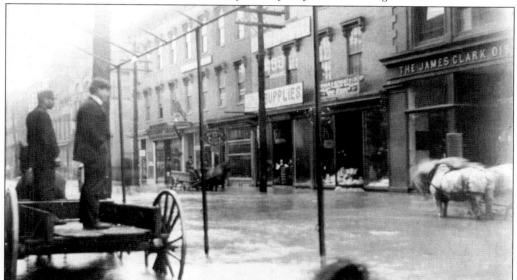

FLOOD IN THE 1880s. One of the earliest photographs of a Cumberland flood shows water running through the streets. The water is approximately two feet high. (From the Herman and Stacia Miller Collection, courtesy of the Mayor and City Council of Cumberland, Maryland.)

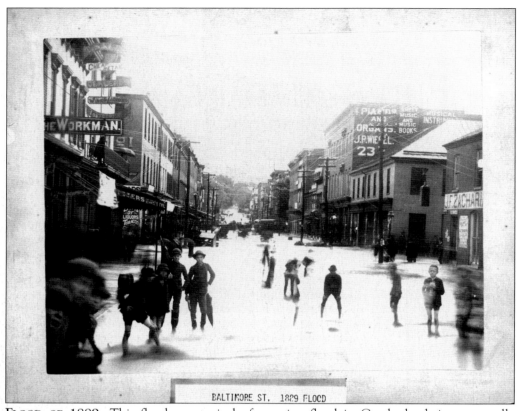

BALTIMORE ST. 1889 FLOOD

FLOOD OF 1889. This flood was typical of a spring flood in Cumberland; it was usually ankle-deep or less. These boys seem to be having a great time playing in the water. (From the Herman and Stacia Miller Collection, courtesy of the Mayor and City Council of Cumberland, Maryland.)

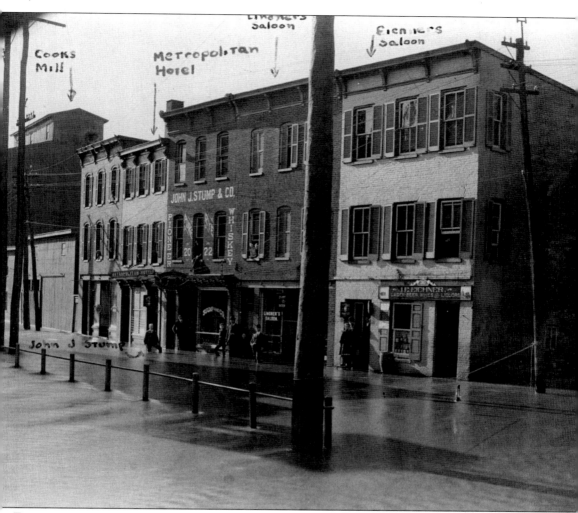

FEBRUARY FLOOD 1902. The floodwater in this photo has reached at least a foot. Imagine how cold and damp the city was for days after the floodwaters receded. (From the Herman and Stacia Miller Collection, courtesy of the Mayor and City Council of Cumberland, Maryland.)

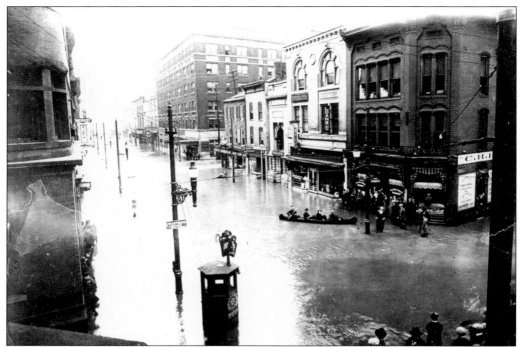

CANOEING ON BALTIMORE STREET. On March 29, 1924, another flood hit Cumberland. Some people found it easier to travel the streets by canoe than to walk through the cold water that was knee deep. This flood caused $4 million in damages. (Courtesy of Allegany County Historical Society.)

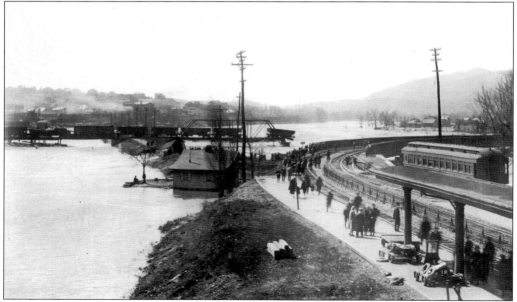

TRAIN WRECK. The floodwaters of 1924 caused a railroad bridge to go out, which led to a train wreck over the Potomac River. Ridgeley, West Virginia, was almost under water when this photo was taken. (Courtesy of Allegany County Historical Society.)

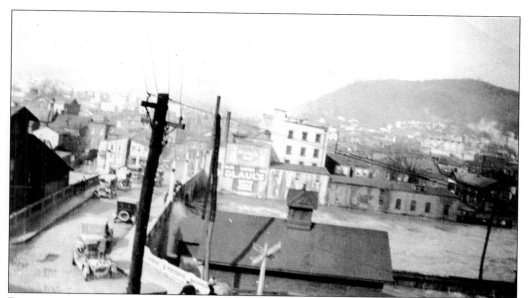

BRIDGE AT VALLEY AND MECHANIC STREETS. Wills Creek is almost overflowing its banks in this photograph. The water had already risen to the second story of the businesses that sat along the creek. (Courtesy of Allegany College of Maryland Library.)

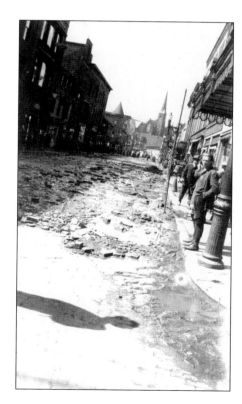

THE AFTERMATH. Cumberland's streets had to be rebuilt after the Flood of 1924. The cobblestones and bricks worked their way out of the street and had to be repaired or replaced. (Courtesy of Allegany College of Maryland Library.)

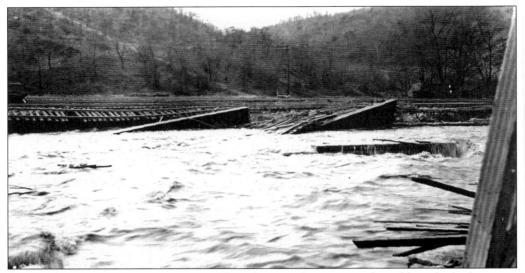

ST. PATRICK DAY FLOOD OF 1936. This photograph gives an idea of how high the water was in 1936. The flood caused $3 million in damages to the city of Cumberland. Here, the water is eroding a railroad track bed in the Narrows. (Courtesy of Allegany College of Maryland Library.)

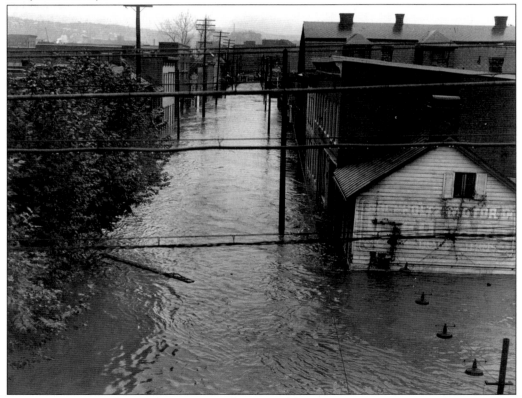

UNDER WATER. Baltimore Street is totally covered by water; in some areas of the street, the water almost reaches the streetlights. (Courtesy of Nadeane Gordon.)

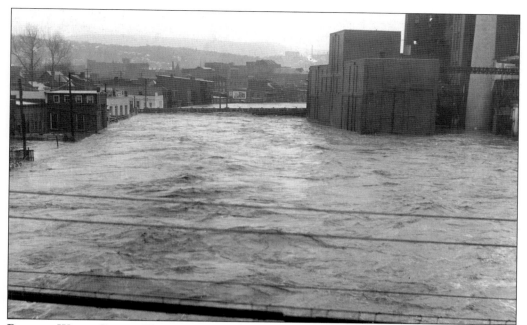

RAGING WILLS CREEK. This view up Wills Creek shows the creek flowing over the Market Street Bridge. On the right is the Old German Brewery. (Courtesy of Nadeane Gordon.)

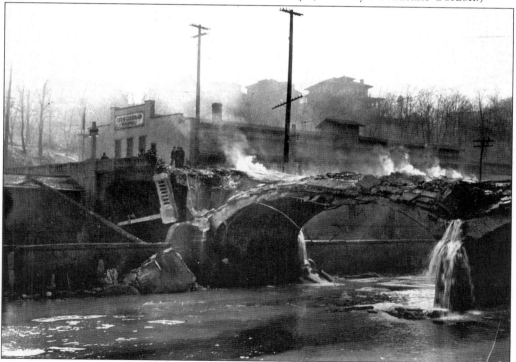

MARKET STREET BRIDGE, AFTER THE FLOOD. Many bridges in Cumberland, like this bridge at Market Street, were destroyed by the raging waters that swept over the stone structures and pulled them apart. (Courtesy of Nadeane Gordon.)

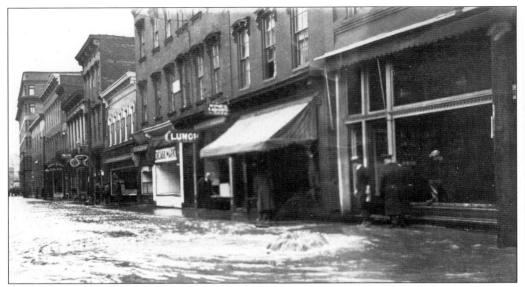

NORTH CENTRE STREET FLOATING. The floodwater made Cumberland look like the canals in Venice—if only it was that romantic. (Courtesy of Nadeane Gordon.)

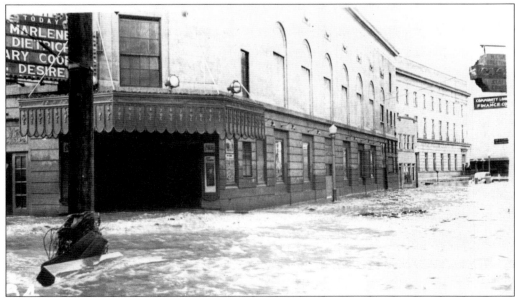

TIDAL WAVE. The water is rushing so fast down the side street that it is causing a small tidal wave in the intersection. (Courtesy of Nadeane Gordon.)

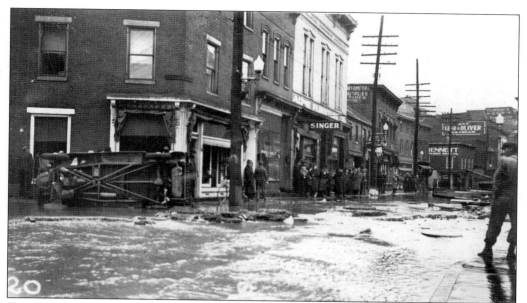

THE MESS LEFT BEHIND. At the corner of Centre and Bedford Streets a car is turned over by the rushing water and debris. As the water receded, the citizens of Cumberland began the long journey towards normality. (Courtesy of Allegany College of Maryland Library.)

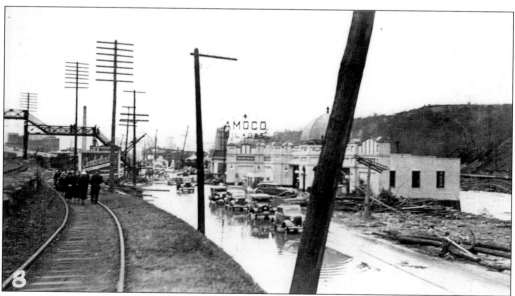

NORTH MECHANIC STREET. This amazing view of Wills Creek at the mouth of the Narrows makes one speechless. The damage that the flood caused is mind boggling; a portion of Route 40 is broken off into the creek and debris is piled at the oil tanks. (Courtesy of Allegany College of Maryland Library.)

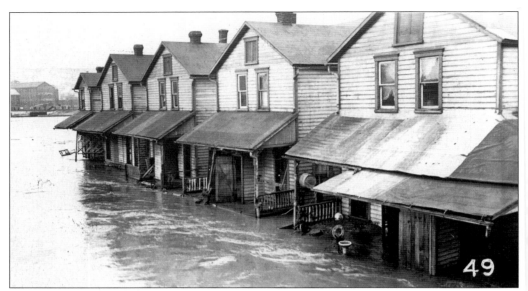

STREETS OF RIDGELEY, WEST VIRGINIA. Ridgeley was hit hard by the Flood of 1936. The Potomac River came right into the front doors of these residences. (Courtesy of Allegany College of Maryland Library.)

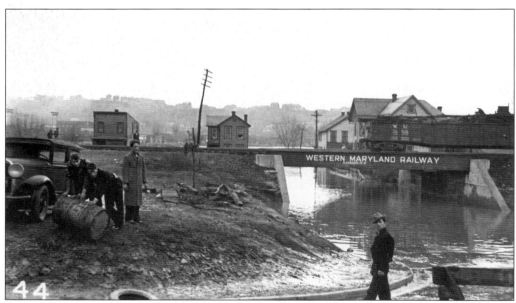

PUSHING AROUND MUCK. Much of Ridgeley was hit harder than Cumberland itself because the town sits where Wills Creek flows into the Potomac River. Ridgeley became submerged in many areas and some residences had "beach front" property until the floodwaters receded. (Courtesy of Allegany College of Maryland Library.)

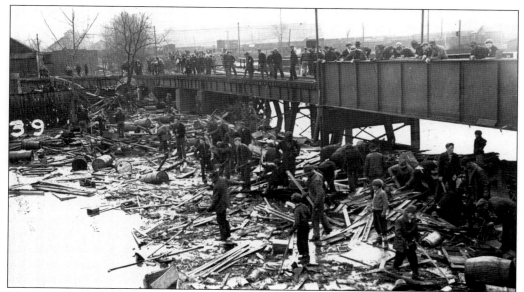

MASSIVE CLEAN UP. The townspeople came together to help clean up and rebuild Cumberland. They worked from sun up to sun down to restore the city's grandeur. (Courtesy of Allegany College of Maryland Library.)

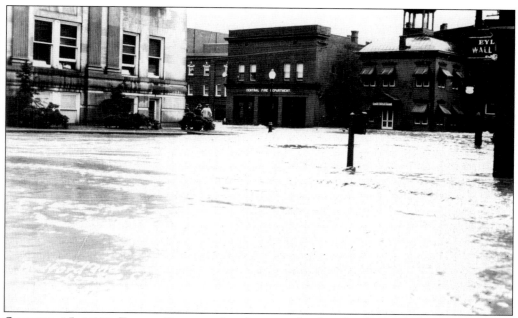

OCTOBER 15, 1942, FLOOD. Six years after the worst flood in Cumberland's history, the Flood of 1942 struck. Again the waters took over the streets and caused mass amounts of damage, but it did not do nearly as much damage as the Flood of 1936. (Courtesy of Allegany County Historical Society.)

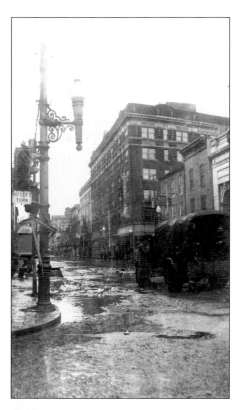

BALTIMORE STREET FLOODED. The United States Army Corp was called in to help clean up of this flood. Not long after the clean up was complete, the plans for Cumberland flood control were put into place. (Courtesy of Allegany County Historical Society.)

NEW BRIDGES AND A FLOOD CONTROL. The United States Army Corps of Engineers was called into Cumberland to build a flood control around Wills Creek. The project was started in the late 1940s and was completed in 1954. In this photo, the engineers are building a new bridge over Wills Creek and what will be part of the flood control system. (From the Herman and Stacia Miller Collection, courtesy of the Mayor and City Council of Cumberland, Maryland.)

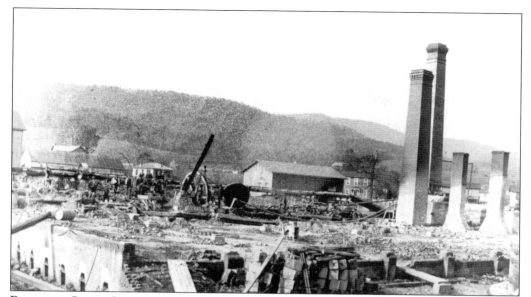

POTOMAC GLASS COMPANY LEVELED. Many factories throughout Cumberland's history were destroyed by fire. Glass factories were at risk of fire because they produced the glass at very high temperatures so that it could be shaped and formed. The Potomac Glass Company opened in 1904 and was destroyed in 1929. (From the Herman and Stacia Miller Collection, courtesy of the Mayor and City Council of Cumberland, Maryland.)

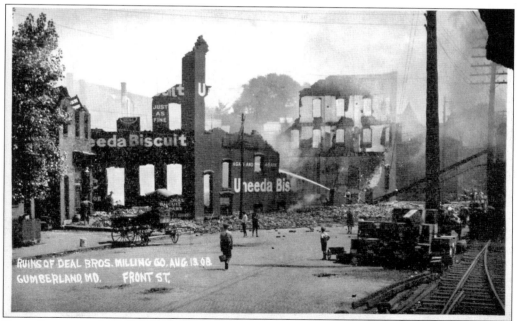

DEAL BROTHERS MILLING COMPANY. This milling company was destroyed by fire in August 1908; the fire also destroyed a couple of neighboring buildings along Glenn and Fulton Streets. (From the Herman and Stacia Miller Collection, courtesy of the Mayor and City Council of Cumberland, Maryland.)

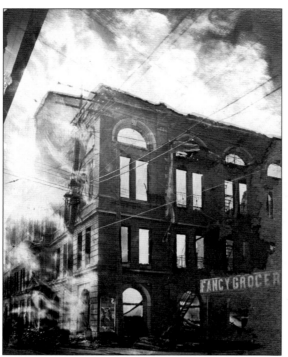

CITY HALL FIRE, 1910. This photograph was taken while city hall was still burning. The roof had already caved in. The firemen were simply trying to contain the fire because they knew that the building was a lost and they did not want the fire to spread to other buildings. (Courtesy of Nadeane Gordon.)

FLAMES AND SMOKE FOR BLOCKS. On a cold March 14, 1910, when City Hall was burning, people could see the flames licking up into the sky and smoke billowing from blocks away. (Courtesy of Allegany College of Maryland Library.)

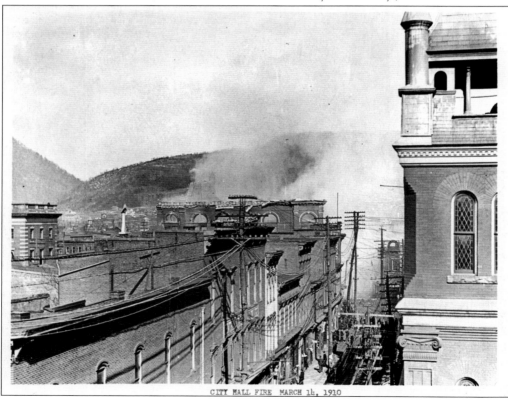

CITY HALL FIRE MARCH 14, 1910

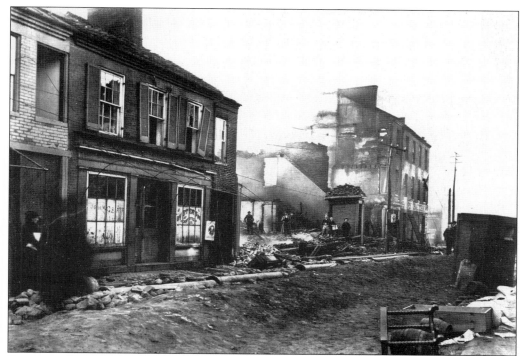

BUSINESS FIRE ON BALTIMORE AND MECHANIC STREETS, 1889. This fire destroyed the business and the merchant's home. It was most unfortunate when a business like this burned because most merchants and their families lived above their businesses. It appears that the fire spread to the next-door business as well. (From the Herman and Stacia Miller Collection, courtesy of the Mayor and City Council of Cumberland, Maryland.)

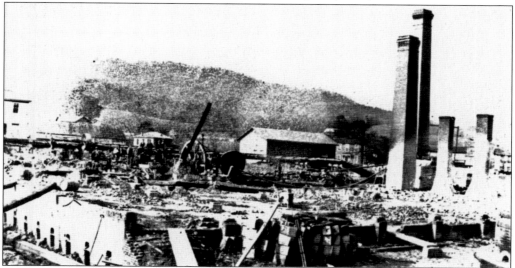

RUINS OF GLASS WORKS. This glass factory on North Centre Street burned to the ground and was never rebuilt. Today there are private homes and businesses where this factory stood. (From the Herman and Stacia Miller Collection, courtesy of the Mayor and City Council of Cumberland, Maryland.)

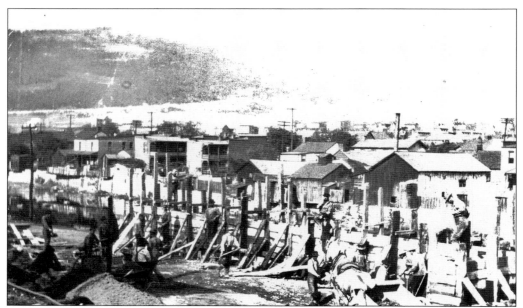

BURNED TO THE FRAME. This building on Mechanic Street near Wills Creek burned to its frame. The fire hoses are still laying on the ground, after putting out the smoldering beams. (From the Herman and Stacia Miller Collection, courtesy of the Mayor and City Council of Cumberland, Maryland.)

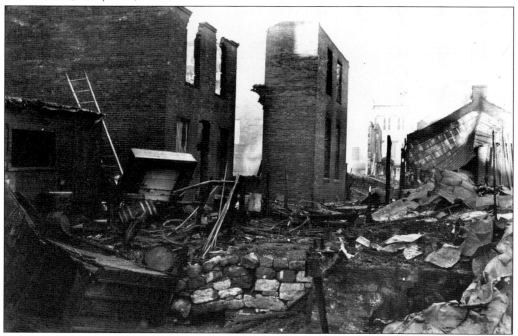

ANOTHER FIRE ON THE NORTH SIDE, 1893. This home near Mechanic Street was leveled. The picture shows that the fire spread to other buildings nearby. Fire was always a big fear of city dwellers because it could mean death and total loss of property. (From the Herman and Stacia Miller Collection, courtesy of the Mayor and City Council of Cumberland, Maryland.)

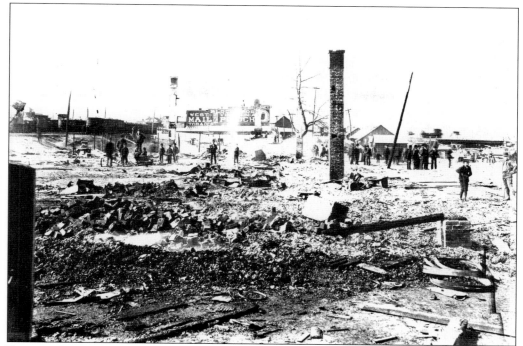

FIRE ON WINEOW STREET, 1893. People came to view the devastation of the blaze. (From the Herman and Stacia Miller Collection, courtesy of the Mayor and City Council of Cumberland, Maryland.)

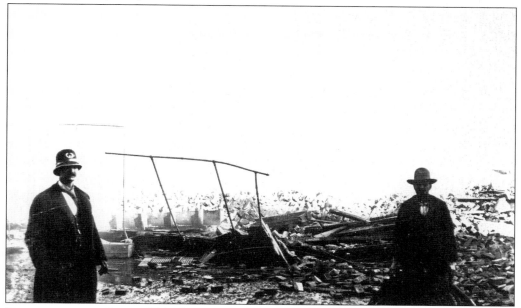

PROTECTING THE SCENE. This photograph of the same fire on Wineow Street shows the police trying to protect the scene. Many times people do not realize the danger that a smoldering house poses. (From the Herman and Stacia Miller Collection, courtesy of the Mayor and City Council of Cumberland, Maryland.)

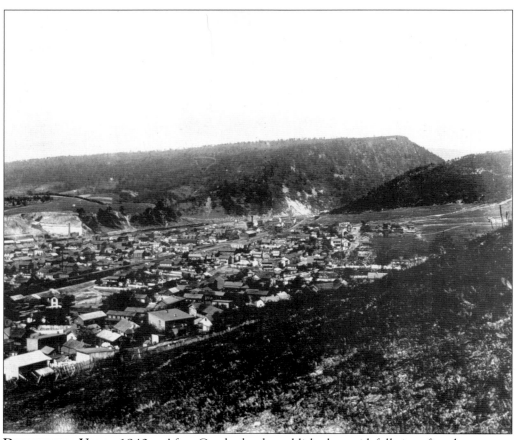

DOWNTOWN VIEW, 1940S. After Cumberland established a paid full-time fire department for the protection of downtown, buildings, for the most part, stayed safe. The city has not changed much since this photo was taken and major fires and floods have stayed at bay. (From the Herman and Stacia Miller Collection, courtesy of the Mayor and City Council of Cumberland, Maryland.)

Nine

AROUND TOWN

The city of Cumberland has always been a beautiful place to explore. In the beginning, the town grew along Wills Creek and the Potomac River, following Native American trails. The town began to expand westward after the construction of Braddock's Road, when people began the first westward migration in the history of the U.S. Many settlers fell in love with the natural beauty and made their homes in the valley between what would be known as Wills, Haystack, and Irons Mountains.

As the city grew it never lost its natural beauty. Developers seemed to love the forests that bordered the city and kept many areas within the city green and beautiful. The people of Cumberland have always taken pride in keeping their city attractive. The beauty of the city is not only in the nature that surrounds it, but also in the buildings themselves. Cumberland boasts over 200 years of architecture present in a three-block radius. It is delightful to take a stroll past George Washington's Headquarters from 1754 and within view see Victorian, Greek Revival, Gothic Revival, and Industrial styles of architecture. Many of the historic buildings have been saved and restored to their original beauty.

The business district of Cumberland has also stayed downtown. It has had many struggles, but Baltimore Street, which has been turned into a pedestrian mall, and Virginia Avenue are still known for locally owned shops and businesses. Like many other towns, the large corporate businesses such as Sears and J.C. Penney's have long left these shopping districts, but local businesses survive.

We have to remember that the growth of the city was not always an attractive picture. This chapter will share the many beauties of Cumberland, but it will also give you a birds eye view and a personal tour of the scenes that many forget. While turning the pages of this chapter the stories of the past will be told through the city's ancestors' eyes.

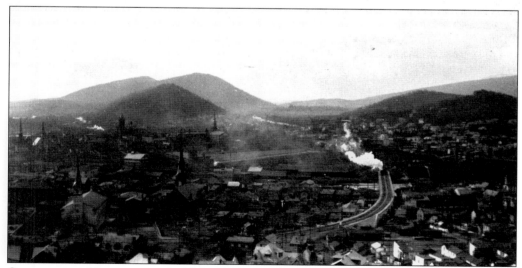

CUMBERLAND NESTLED IN THE VALLEY, 1890. This photograph of Cumberland sitting in the valley of the Narrows is an exquisite reminder of why settlers thought the area was so beautiful and wondrous. The city grew up along the Potomac River bed and Wills Creek and then expanded into the neighboring hillside. (From the Herman and Stacia Miller Collection, courtesy of the Mayor and City Council of Cumberland, Maryland.)

THE BEGINNING OF CUMBERLAND. Cumberland has not always been full of wonderful architecture and large factory buildings. In the city's beginnings, it only had small modest houses like these. The families built their homes near the river and creek to have easy access to water for drinking and cleaning. (From the Herman and Stacia Miller Collection, courtesy of the Mayor and City Council of Cumberland, Maryland.)

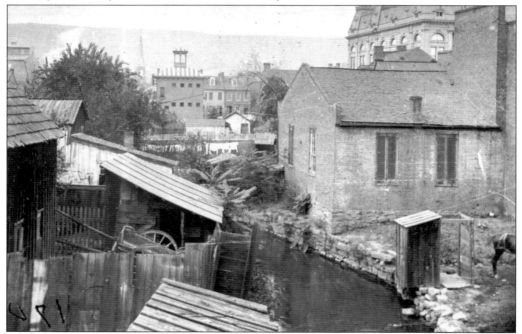

BEHIND THE SCENES. When people think of cities in the past, they usually have a romantic view of grandeur rather than the day-to-day scenes of life. This photograph is a behind-the-scenes look into someone's backyard and privy. (From the Herman and Stacia Miller Collection, courtesy of the Mayor and City Council of Cumberland, Maryland.)

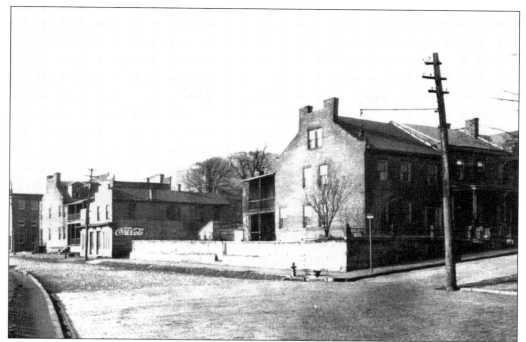

THE STREETS ARE LAID. On the east side of Cumberland at Henderson, Fulton, and Charles Streets, the roadway and sidewalks are being graded. As Cumberland developed, the streets were paved with cobblestone and brick. When bricks were readily available houses were also built out of brick instead of wood. (From the Herman and Stacia Miller Collection, courtesy of the Mayor and City Council of Cumberland, Maryland.)

THE COUNTRYSIDE. Not all of the area was transformed into a metropolis—much of the area remained rural like this picturesque farm just southeast of Cumberland. (From the Herman and Stacia Miller Collection, courtesy of the Mayor and City Council of Cumberland, Maryland.)

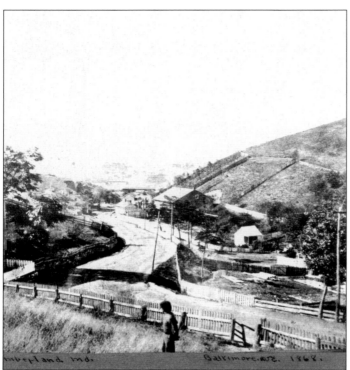

BALTIMORE AVENUE, 1868. Before it was booming with industry and transportation ports, Cumberland was a little frontier town. Even after the railroad pushed into town, the people of Cumberland were simple folks surviving on the land. (From the Herman and Stacia Miller Collection, courtesy of the Mayor and City Council of Cumberland, Maryland.)

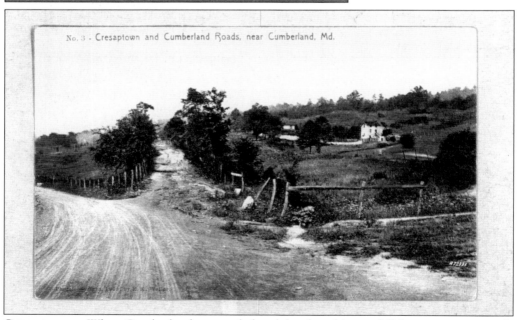

No. 3 - Cresaptown and Cumberland Roads, near Cumberland, Md.

CRESAPTOWN. When Cumberland was settled and developed into a full functioning city with businesses, factories, and transportation systems, other communities began. Many people did not want to live in town. This is Cresaptown in its infancy; it looks to be a one-horse town. (From the Herman and Stacia Miller Collection, courtesy of the Mayor and City Council of Cumberland, Maryland.)

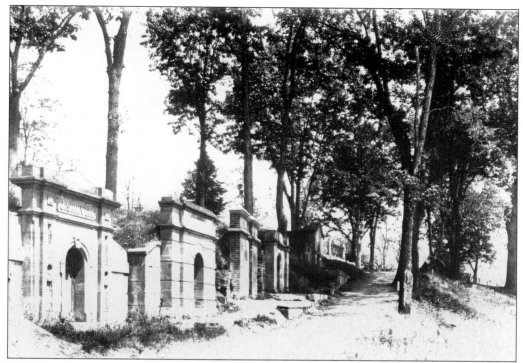

ROSE HILL CEMETERY. One of Cumberland's first cemeteries was built off of Fayette Street. As the city grew, it became necessary to have a proper burial place for the dead. (From the Herman and Stacia Miller Collection, courtesy of the Mayor and City Council of Cumberland, Maryland.)

NEW AND OLD. This photograph depicts the growth that Cumberland experienced. Older homes were located next to large Victorians; soon, the older homes would be bought and torn down. (From the Herman and Stacia Miller Collection, courtesy of the Mayor and City Council of Cumberland, Maryland.)

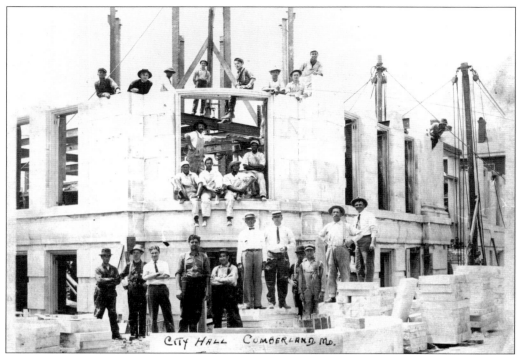

CITY HALL UNDER CONSTRUCTION, 1911. Cumberland had a great deal of rebuilding to do after the many fires and floods it experienced. This is Cumberland's third city hall; it is still used today. The prior two were destroyed by fire. (From the Herman and Stacia Miller Collection, courtesy of the Mayor and City Council of Cumberland, Maryland.)

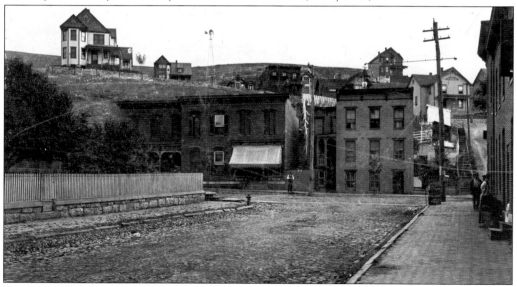

DECATUR STREET AND BALTIMORE AVENUE, 1910. Cumberland's east side did not go through a building boom until after the 1920s. This area of Cumberland was on the outskirts of town. Later, this area would become home to three hospitals and the first location for Allegany County Community College. (Courtesy of the Allegany County Historical Society.)

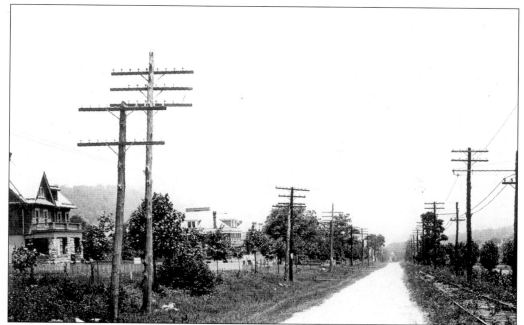

LaVale National Highway, 1914. LaVale prospered once the National Road was built. LaVale was a real estate prospect known as "The Vale," but the name was somehow changed over the years. Many people bought land in LaVale to get out of the city of Cumberland. More people built in LaVale when the Electric Trolley line was built through town. (Courtesy of Allegany County Historical Society.)

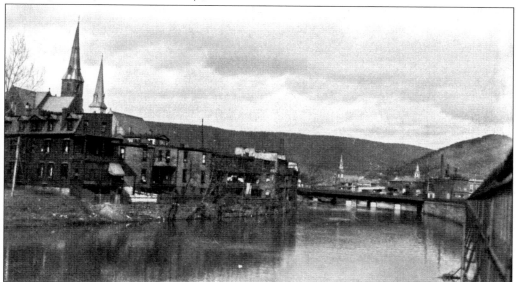

The End of Wills Creek. This is a photograph of Wills Creek flowing between the Western Maryland Railway Station and Greene Street, looking toward Wills Creek Bridge at Baltimore Street. After the construction of the flood control, the landscape of the city changed. (From the Herman and Stacia Miller Collection, courtesy of the Mayor and City Council of Cumberland, Maryland.)

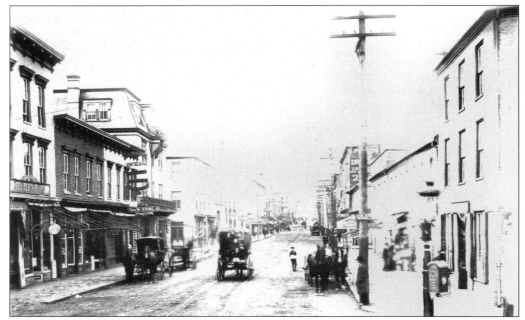

BALTIMORE STREET. Looking east from the Western Maryland Railway Station is a beautiful scene of the busiest street in Cumberland. Streets were much wider and sidewalks much more narrow. (From the Herman and Stacia Miller Collection, courtesy of the Mayor and City Council of Cumberland, Maryland.)

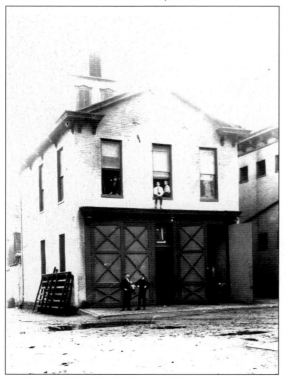

PIONEER HOSE COMPANY, 1900. The firehouse stood next to City Hall Square and the Chamber of Commerce building. However, the close proximity of the firehouse was not enough to save the Academy of Music when it caught fire in 1910. (From the Herman and Stacia Miller Collection, courtesy of the Mayor and City Council of Cumberland, Maryland.)

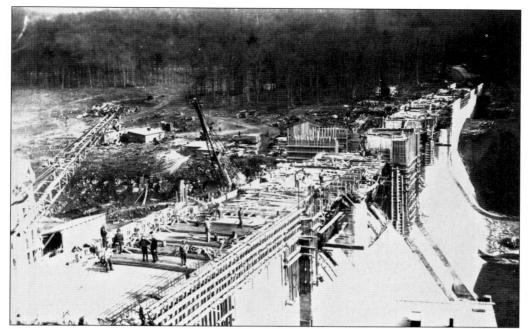

CONSTRUCTION OF KOON DAM, 1932. This dam became the major water source for the city of Cumberland and is still used today, along with Lake Gordon. To supply water to the city residents, the dams were built in nearby Bedford County, Pennsylvania. (From the Herman and Stacia Miller Collection, courtesy of the Mayor and City Council of Cumberland, Maryland.)

HOME OF DR. THOMAS KOON. The Koon Dam near Centerville, Pennsylvania was his brainchild; Dr. Thomas Koon's home was located on Washington Street. (Courtesy of Allegany County Historical Society.)

WASHINGTON STREET, 1894. Winters are not what they use to be in Cumberland. Washington Street at Prospect Square looks like a winter wonderland after a snowstorm hit the area. (From the Herman and Stacia Miller Collection, courtesy of the Mayor and City Council of Cumberland, Maryland.)

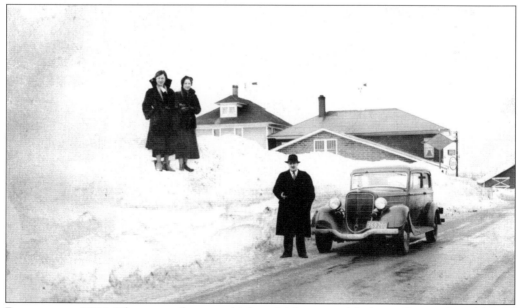

BLIZZARD OF 1936. The snow piles are as high as this house on Mechanic Street after a blizzard hit Cumberland in late January 1936. The city municipal employees cleared the streets for cars; the sidewalks are another story. (From the Herman and Stacia Miller Collection, courtesy of the Mayor and City Council of Cumberland, Maryland.)

Ten
PEOPLE WATCHING

It has always been human nature to watch others in action. The invention of the camera gave "people watchers" a permanent glimpse into a person's life. Like the old saying goes, "a picture is worth a thousand words."

This chapter offers a brief chance to look into the past and allows us to see the people who shaped the city streets, buildings, and hangouts. These photos give faces to generations forgotten. If it was not for these photographs, these citizens of Cumberland may not have been remembered.

This chapter is dedicated to all those who have made Cumberland the city it was, the city it is, and the city it will become.

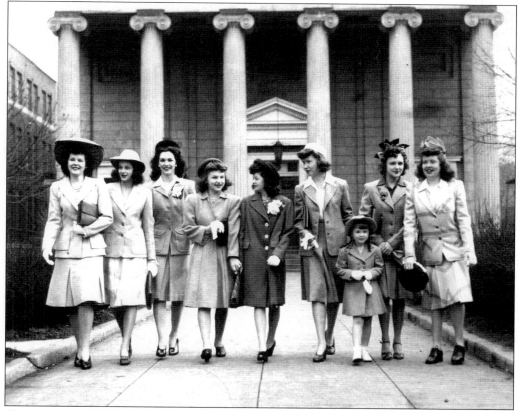

CHURCH GOERS, 1940. These eight women and child are leaving the Church of St. Patrick after Sunday service. Churches have always played a huge role in the Cumberland's history. (From the Herman and Stacia Miller Collection, courtesy of the Mayor and City Council of Cumberland, Maryland.)

THE DISCUSSION. This couple seems to be having a very important conversation on Baltimore Street. The gentleman appears to be reaching for his watch; perhaps one of them is late for their meeting. (From the Herman and Stacia Miller Collection, courtesy of the Mayor and City Council of Cumberland, Maryland.)

BALTIMORE AND GEORGE STREETS, 1911. This couple acts as if they have been caught unexpectedly; their conversation must be too private even for a photograph. (From the Herman and Stacia Miller Collection, courtesy of the Mayor and City Council of Cumberland, Maryland.)

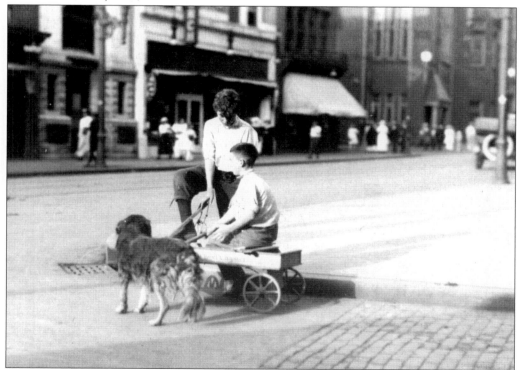

JUST PLAYING AROUND. What is a boy without his dog? It seems that the dog is just as much a part of the gang as the boys. (From the Herman and Stacia Miller Collection, courtesy of the Mayor and City Council of Cumberland, Maryland.)

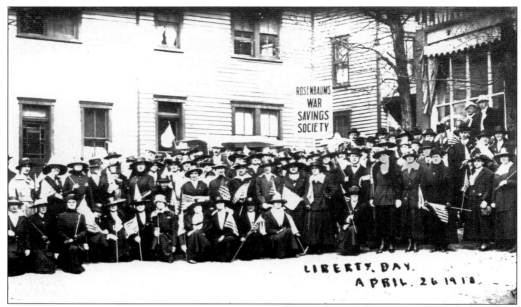

LIBERTY DAY, 1918. Rosenbaum's War Savings Society was a group of ladies who displayed their loyalty to their country by selling war bonds. (From the Herman and Stacia Miller Collection, courtesy of the Mayor and City Council of Cumberland, Maryland.)

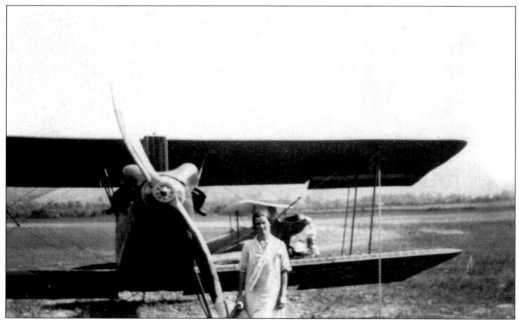

MEXICO FARMS AIRPORT. This 1930s photograph shows the airstrip at Mexico Farms in its glory. It looks like we may have an Amelia Earhart fan. (From the Herman and Stacia Miller Collection, courtesy of the Mayor and City Council of Cumberland, Maryland.)

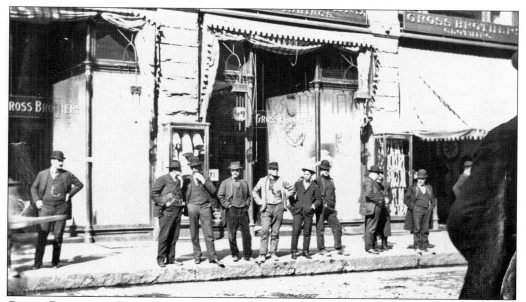

GROSS BROTHERS CLOTHING. These men are hanging out in front of this men's clothing apparel store on Baltimore Street. (From the Herman and Stacia Miller Collection, courtesy of the Mayor and City Council of Cumberland, Maryland.)

PRESIDENT LYNDON B. JOHNSON IN CUMBERLAND, 1964. Many presidents passed through Cumberland on their way west on the National Road. LBJ stopped in Cumberland briefly in 1964 and spoke on the steps of City Hall. (Courtesy of Allegany College of Maryland Library.)

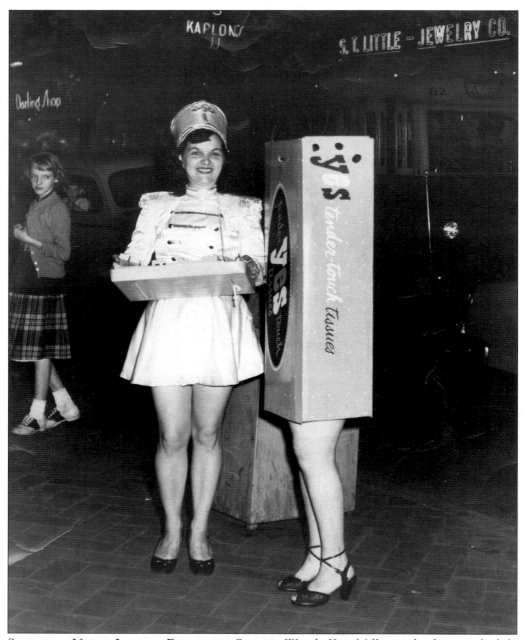

SATURDAY NIGHT LIVE ON BALTIMORE STREET. Wanda Yost Miller works the crowd while handing out samples of tissues on Baltimore Street in 1950. (Courtesy of Wanda Yost Miller.)

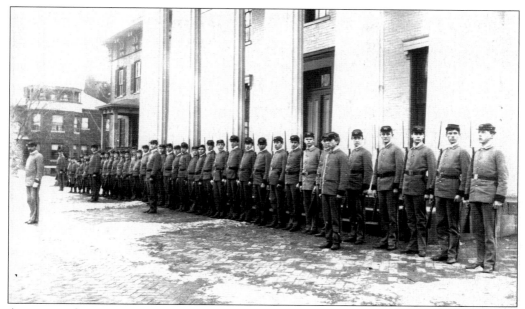

ALLEGANY COUNTY CADETS, 1892. These young boys and men were whipped into shape at the Allegany County Academy. They resemble Civil War soldiers. (From the Herman and Stacia Miller Collection, courtesy of the Mayor and City Council of Cumberland, Maryland.)

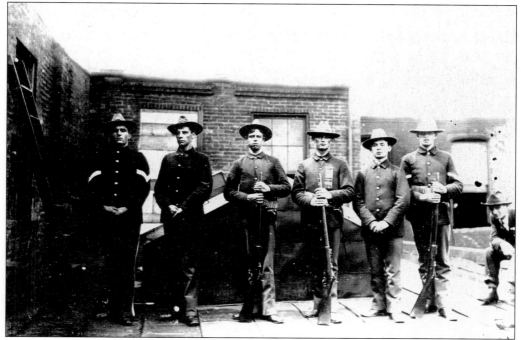

COMPANY "C," MARYLAND NATIONAL GUARD ARMORY, 1899. The Old Armory on Centre Street was used by the National Guard. Many people remember roller-skating or playing bingo in this building. (From the Herman and Stacia Miller Collection, courtesy of the Mayor and City Council of Cumberland, Maryland.)

CUMBERLAND, MY QUEEN CITY

Wandered this whole world over--
Felt the depth of the deep blue sea;
Gloried in a cloud floored sky,
But there's one place that's captured me.

She's the queen of my heart in the summertime;
The cool autumn breeze in the fall,
She's the best place in this world--
I'm telling you, sir,
The queen that I love most of all.

She's the streets that I tread day and night time,
The friend that I greet, know them all,
There's no place in this wide world I'd rather be, sir,
Queen City, I love you most of all.

Cumberland, Cumberland, lend me your ear.
While I sing of a love as strong as man
Let these words sound the whole world over;
Resound the love of the folk for Cumberland.

She's the queen of my heart in the summertime;
The cool autumn breeze in the fall--
She's the one place on this earth I want to be, sir,
Queen City, I love you most of all.

"CUMBERLAND, MY QUEEN CITY." (Courtesy of Allegany College of Maryland Library.)